Postcard History Series

Long Island City

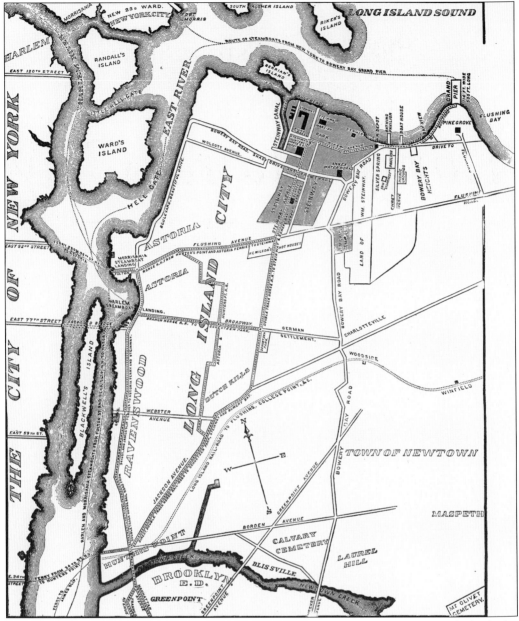

This map of Long Island City, printed in 1896, is a good reference for place-names for both the neighborhoods and the North Beach points of interest mentioned in this book.

POSTCARD HISTORY SERIES

Long Island City

Greater Astoria Historical Society
with Matt LaRose, Stephen Leone, and Richard Melnick

ARCADIA
PUBLISHING

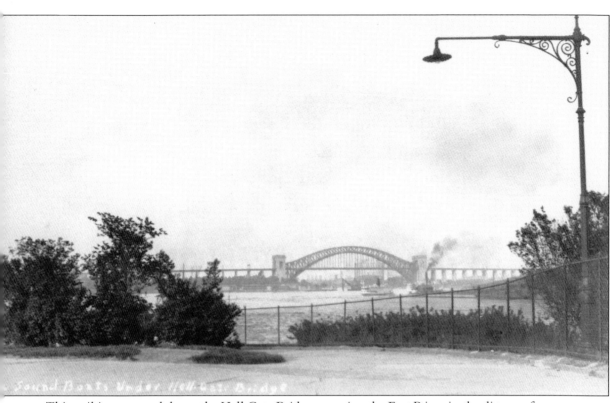

This striking postcard shows the Hell Gate Bridge spanning the East River in the distance from Carl Schurz Park near the mayor's residence at Gracie Mansion.

One

SHORELINE AND BRIDGES

Communities situated near sources of water have always prospered and Long Island City, located fortuitously along the East River, is no exception. To the townspeople, the East River's meaning lies much deeper than being a divine gift from above. The river, with its ever-restless tides and currents, is a key to understanding Long Island City's soul. It is from these shores that ancestors built their homes and made their fortunes. It embodies the vision of the future—a vibrant blend unifying a fiercely independent community. To paraphrase Carl Sandburg, the East River is a river with big shoulders.

While it never boasted an equivalent to the Hudson River's charm, finding ways to cross the East River has inspired large-scale technological masterpieces, for behind its bridges lie true art. Who would not be stirred by the lilt of the Queensboro Bridge or be impressed with the handsome span of the Triborough? The Vernon Avenue Bridge, at one time a utility bridge across the Newtown Creek, did a yeoman's job. And not to be overlooked is the Hell Gate Bridge, a rail bridge; one need not discount its august presence over Astoria Park.

Access to the waterfront is as important today as it was in Colonial times, as it is a source of life. It offers a unique blending of nature, technology, and community. It is only along the shoreline, as it stretches along the East River, that people are allowed a firsthand experience of its vigor. Gantry Plaza State Park, with its restored float bridges, is a monument to the community's industrial heritage. Astoria Park, Socrates Sculpture Park, Rainey Park, and Queensbridge Park still offer visitors a pleasurable contrast between the river's pulse and the natural environment. One would be pressed to find similar juxtapositions like this in all of New York City.

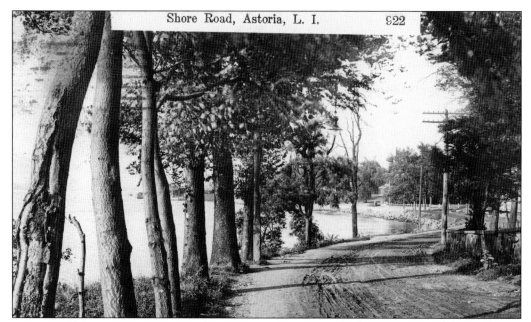

A dirt road, the future Shore Road, leads to the estates in northern Astoria. Just east of the bend is the high ground that now supports the Queens tower of the Triborough Bridge in Astoria Park. This is one of the earliest postcards of the community.

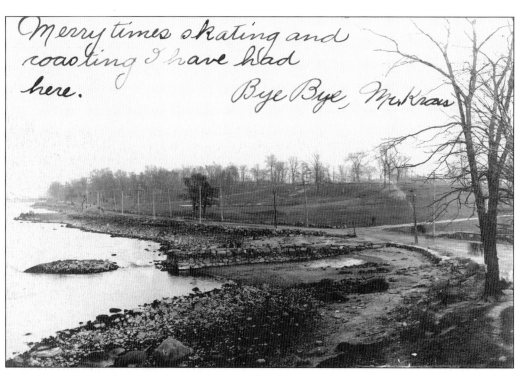

In this fine wintry view of Shore Road, shoals, rock outcroppings, and the river make a pleasant view. Anna Miller of 497 Ninth Avenue (now 38th Street) in Astoria writes, "Merry times skating and coasting I have had here. Bye Bye, Mr. Kraus."

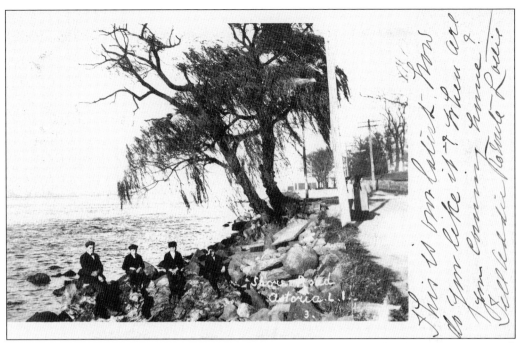

"This is our latest, how do you like it? When are you coming home? Tell Addie to write. Lottie." The four lads on the large coastal rocks give perspective to the shoreline at Shore Road. Note the poles; were they for telephone or telegraph?

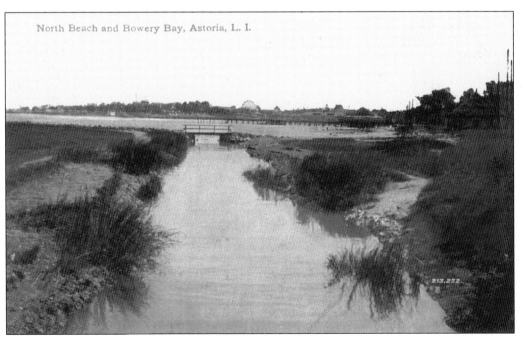

North Beach and Bowery Bay, Astoria, L. I.

This view of North Beach is from Bowery Bay. Although thousands of people flocked to North Beach Amusement Park on weekends during the summer, pristine waterfront remained in view as late as 1900. This was New Amsterdam's poor farm (bowery, or *bouwerie* in Dutch).

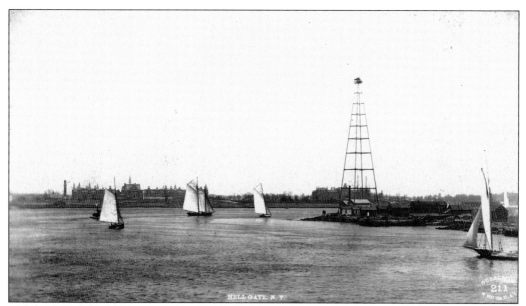

The Hell Gate Light Tower, the largest tower of its time (1884–1886) tried to illuminate the dangerous Hell Gate with powerful lights. Unexpected fog blinded the ships, and the experiment was short-lived. An early card remembers the effort.

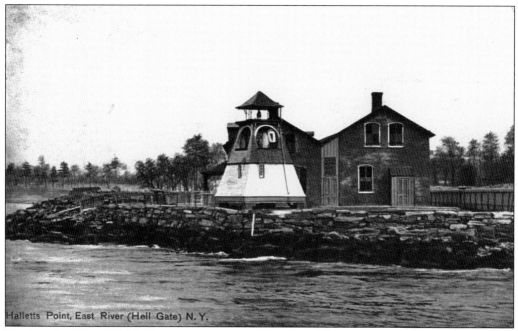

Halletts Point, East River (Hell Gate) N. Y.

During the War of 1812, Fort Stevens was at strategic Hallets Point in the East River at the infamous Hell Gate. Considered the most dangerous channel in New York harbor, authorities built both a lighthouse and foghorns to warn the unwary and unlucky.

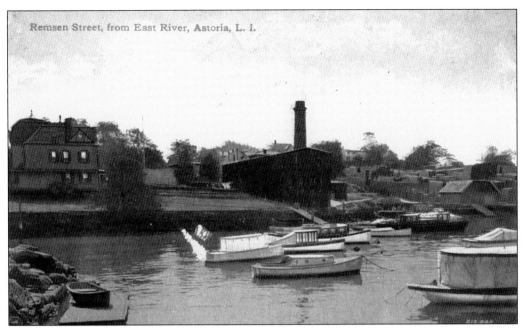

Remsen, later 12th, Street runs down to Pot Cove on the East River in Old Astoria. This quiet backwater in the turbulent Hell Gate was a harbor for small boats. Pot Cove got its name from artifacts left at a Native American village at the site.

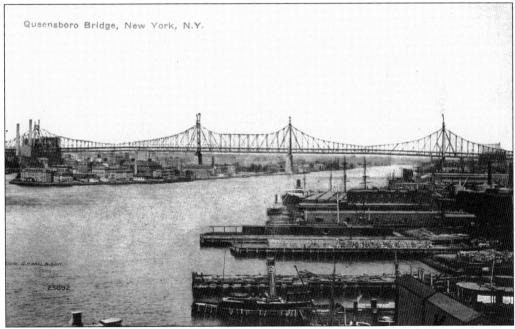

This marvelous view of the Hunters Point waterfront and the Queensboro Bridge is one of the finest ever to show the river's commercial activity. At the left is Roosevelt Island's southern tip, and to the right are the massive steel car floats (barges that carried railcars) at the Long Island Rail Road terminus.

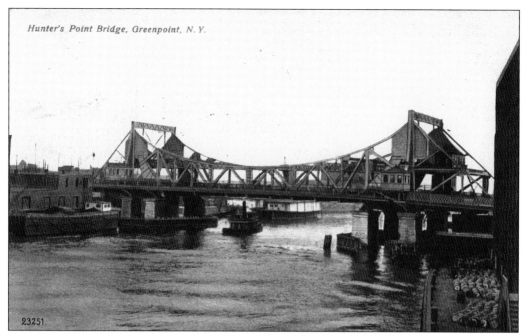

Hunter's Point Bridge, Greenpoint, N.Y.

23251.

The Ravenswood, Hallett's Cove, and Williamsburgh Turnpike and Bridge Company completed the first road along the East River in 1840. The Queens section is Vernon Boulevard. It built Penny Bridge, the first bridge over Newtown Creek, in 1836. This is a later bridge completed about 1905.

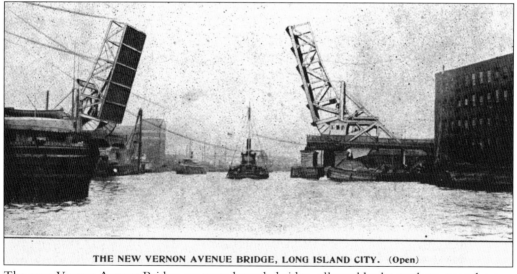

THE NEW VERNON AVENUE BRIDGE, LONG ISLAND CITY. (Open)

The new Vernon Avenue Bridge, an open bascule bridge, allowed barks, tankers, tugs, barges, and all types of vessels to pass into and out of the three-and-a-half-mile Newtown Creek, a tidal arm of the East River. To the right is the future Greenpoint Manufacturing and Design Center (GMDC) on Manhattan Avenue in Brooklyn.

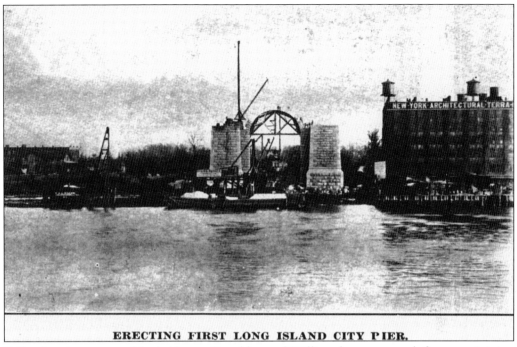

ERECTING FIRST LONG ISLAND CITY PIER.

Following the success of the bridges to Brooklyn and Williamsburg, proposals for a span joining midtown Manhattan and Long Island City, Queens, were met with enthusiasm by city leaders and the public. Massive granite blocks built the Long Island City pier of the Queensboro Bridge.

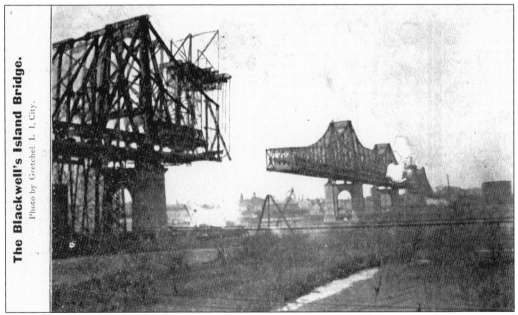

Blackwell's Island became Welfare Island (1921) and later Roosevelt Island (1973). The cantilever-style bridge chosen for this location was considered a more efficient design than the more common suspension spans built elsewhere on the East River. A cantilever bridge was cheaper to build and made access to Roosevelt Island easier than a suspension bridge.

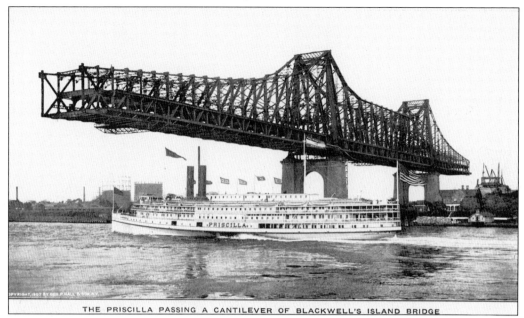

THE PRISCILLA PASSING A CANTILEVER OF BLACKWELL'S ISLAND BRIDGE

Looking northeast from the Manhattan shoreline, the *Priscilla*, an excursion steamer, chugs north up the East River's West Channel. Beyond the boat's bow are the huge Ravenswood gas tanks, now the site of Keyspan's colossal Ravenswood power plant "Big Allis." The bridge nears completion.

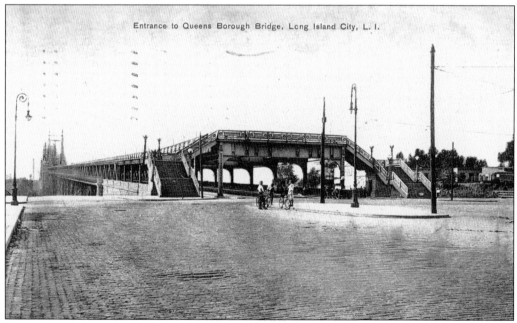

Briefly Bridge Plaza, as the Queens entrance to the Queensboro Bridge was originally called, was a stunning gateway park into the borough. After a few years, its flowers and grass were replaced by the brutally huge, eight-track Queensboro Plaza elevated station. The once verdant plaza echoed with a din of pedestrians, trolleys, elevated trains, trucks, automobiles, and horses.

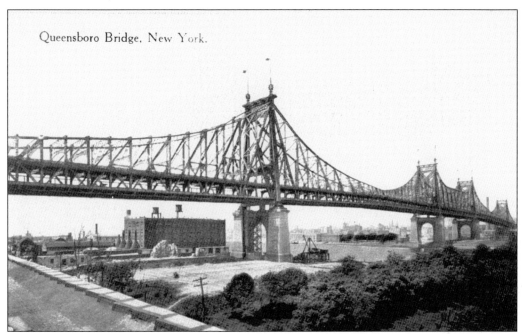

Queensboro Bridge, New York.

This view from a Queens rooftop looks southwest toward Manhattan. South of the bridge is the New York Architectural Terra Cotta factory, provider of a decorative ornamentation that defined a generation of landmarks, including the Ansonia Hotel, Carnegie Hall, and the Plaza Hotel. The trees on the right foreground became Queensbridge Park in 1939.

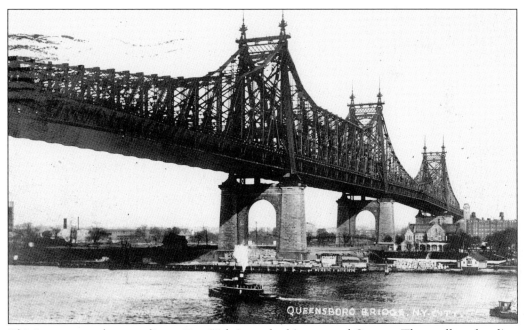

This image was taken standing at East 55th Street looking toward Queens. The small tug heading upriver gives perspective to the bridge's scale. The warden's residence, on Blackwell's Island, is the house just south of the bridge pier. The long steel spires on each tower, originally used as flagpoles, were removed in 1960.

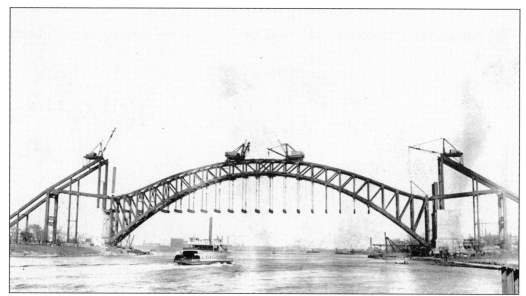

The New York Connecting Railroad East River Arch Bridge was the largest rail bridge in the world when it opened in 1917. Its four tracks carried two each of freight and passenger trains. In October 1915, when the two halves of the massive 1,017-foot arch met at mid-river (about the time of this picture), they were nearly perfectly aligned. It was an unprecedented engineering achievement.

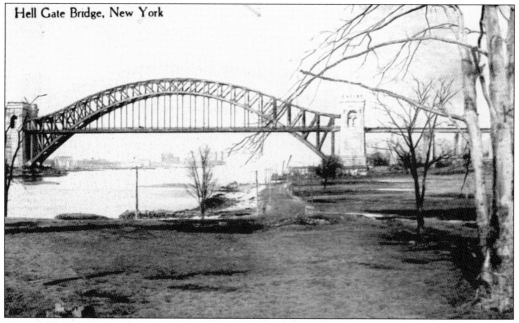

Hell Gate Bridge, New York

The Hell Gate Bridge looms over the newly minted Astoria Park. Although this was one of the narrowest stretches on the East River, it was also one of the most dangerous. Soundings showed ledges just beneath the surface next to plunging, 100-foot crevasses that were among the deepest holes in the harbor.

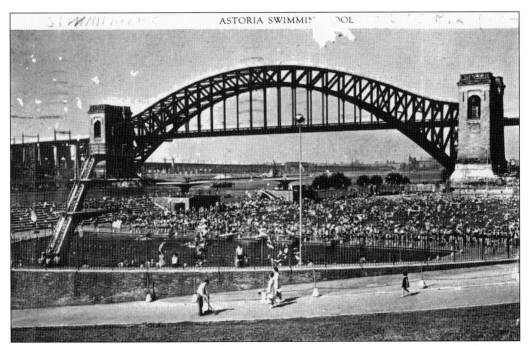

A crowd cools off at what Robert Moses called his favorite pool in the city parks system, Astoria Pool. Recognizing its cutting-edge design and construction, the United States Olympic Committee held its 1936 and 1964 swimming and diving trials here.

VIEW SHOWING HELL GATE BRIDGE AND ASTORIA PARK, L. I., N. Y. 509

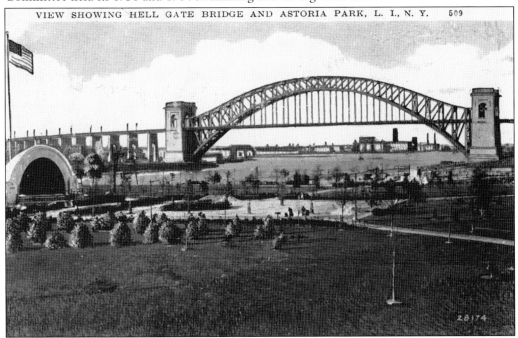

Few recall that Astoria Park once had a band shell just south of the pool. Today this area has a quarter-mile running track as well as walking and bike paths. Astoria Park is the largest public park in northwestern Queens. It remains a gem with one of the most pleasing views of the East River.

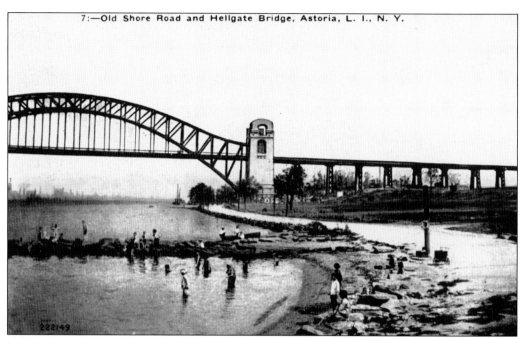

At Scaly Rocks near Shore Road, bathers enjoying the relative calm of a small cove were wary to venture too far into the river. At the aptly named Hell Gate, treacherous tides and currents could very well sweep the careless swimmer away. See the bottom image on page 10 for an earlier view of this location.

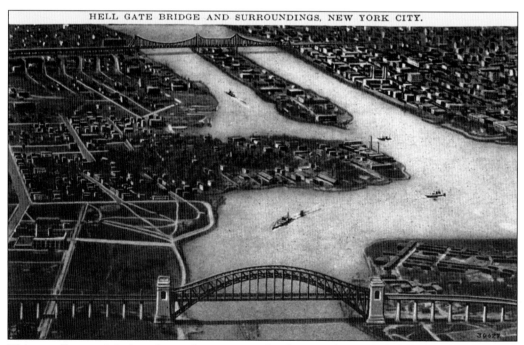

HELL GATE BRIDGE AND SURROUNDINGS, NEW YORK CITY.

This excellent aerial view shows the great swath of Long Island City between the Hell Gate Bridge and the Queensboro Bridge during the 1920s. The Astoria peninsula juts out into the river. Roosevelt Island is downstream. Wards Island is at the lower right.

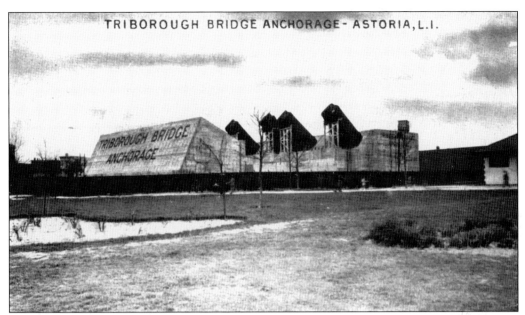

The Triborough Bridge anchorage in Queens sat on a large outcrop of Fordham gneiss, the strong bedrock that supports much of the Bronx. The only bedrock near the surface of all Long Island is on the narrow strip between 21st Street and the river.

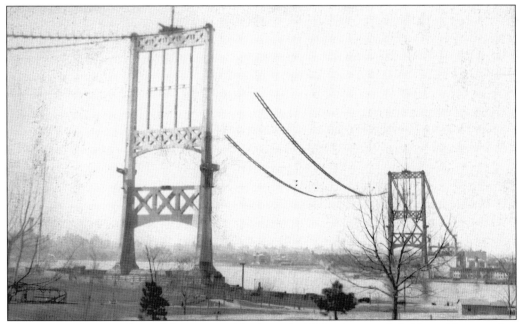

This unique photograph, used for a postcard in the early 1930s, shows only bridge cables spanning the East River. The massive steel latticework supporting its roadbed awaits installation. A young Astoria Park nestles around the tower's base.

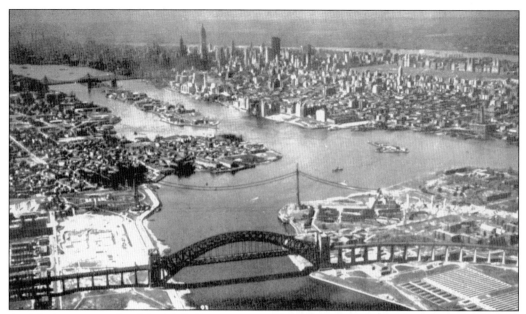

Aerial view postcards of the Hell Gate were popular. This is similar to the Hell Gate card on page 20 except for the uncompleted Triborough Bridge. Wards Island, on the right, has a sewage treatment plant.

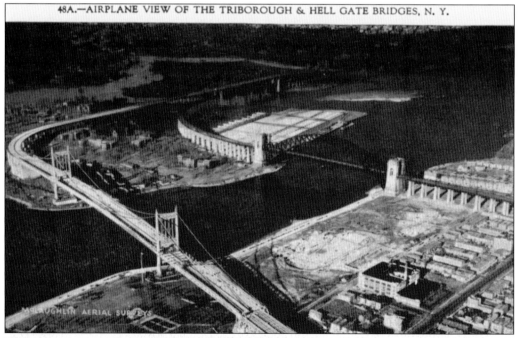

48A.—AIRPLANE VIEW OF THE TRIBOROUGH & HELL GATE BRIDGES, N. Y.

This is another popular aerial view, this time facing northwest. Taken a few years later in the mid-1930s, it shows the Triborough Bridge and the Astoria Pool under construction in Astoria Park. The former Eagle Electric Plant overlooking Astoria Park is now the Riverview Apartments.

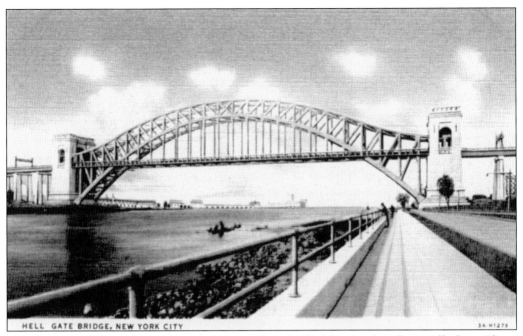

A fine view of the Hell Gate Bridge shows Astoria Park's completed seawall along Shore Boulevard. This tranquil scene belays the horrific *General Slocum* steamboat disaster. More than 1,000 people were killed when the excursion steamer caught fire in 1904.

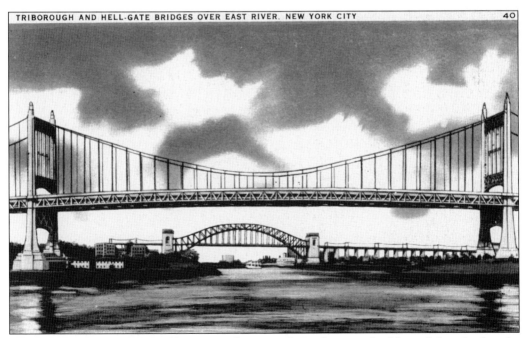

Both bridges that span the Hell Gate are shown to their advantage in this card that also has the inevitable steamer making its way through the strait.

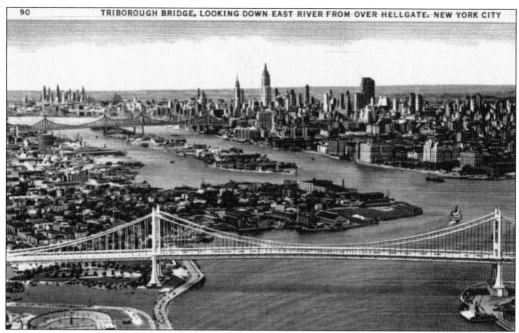

This fine view of the Triborough Bridge shows the sweep of the East River's Hell Gate as it bends around the Astoria peninsula. Roosevelt Island and Manhattan are in the background.

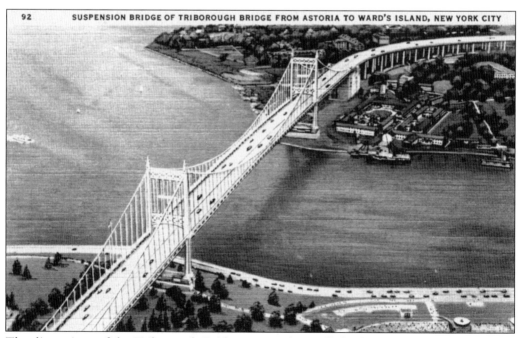

The dimensions of the Triborough Bridge are on the card's back. The suspension span cost $64 million, is 2,800 feet long, and each cable is comprised of 9,176 strands of wire.

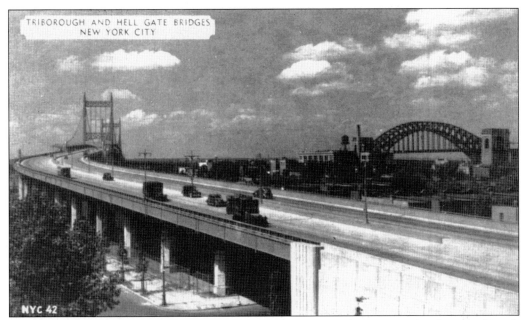

The Triborough Bridge is still considered one of the most complex engineering feats attempted. It is actually three bridges: a suspension span over the Hell Gate, a steel truss over the Bronx Kill, and a lift bridge span above the Harlem River. To the right is the Hell Gate Bridge.

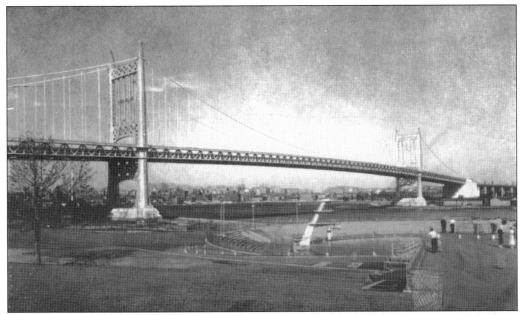

Trees hide this unique perspective of Astoria Pool's diving platform today. The Triborough Bridge's name comes from its role in connecting three of New York City's boroughs, Queens, Manhattan, and the Bronx.

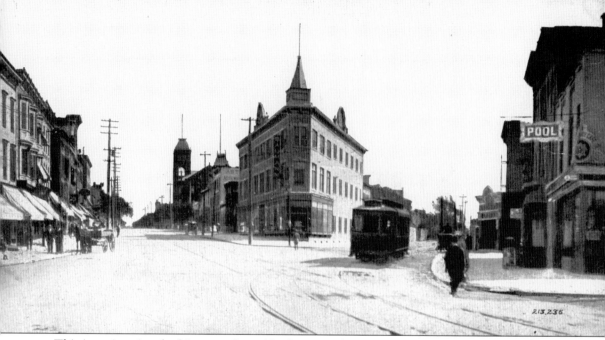

This is a nice view looking east from 21st Street at the intersection of Astoria Boulevard (on the left) and Newtown Avenue (on the right). Once called "Andersen Square," it is sometimes confused with "Astoria Square" (the intersection of these streets to the west of 21st Street). In the distance is the mansard tower of Mount Carmel School.

Two

STREET SCENES

One would not know it from its urbanized appearance today, but Long Island City was first comprised of a fascinating mix of both tree-lined and industrial neighborhoods. Dignified homes, be they the imposing mansions overlooking the East River or smaller-scaled residences on its shaded streets, all represented the lifestyle residents enjoyed. Merchant activity bustled on Steinway Street, Ditmars and Vernon Boulevards, Broadway, and Grand Avenue (today's 30th Avenue), but absent from the scene were commercial titans like those in Manhattan or even Brooklyn. Instead, shops with graceful awnings—the tailor, grocery, general goods store—presented themselves to the public, their owners valuing every customer.

Although Long Island City has undergone many changes since then (which New York City community has not?), enough physical history remains for those wishing to explore. Local landmarks are still present, as in the Sunnyside Yards, the courthouse, or the venerable mansions of Old Astoria Village. These are easy to find and appreciate. No less deserving of recognition is the Mathews Model Flats, a lesson in working-class housing. The renowned Steinway and Sons piano company was launched here (few realize that the Steinway name extends to subway planning and a venture into car manufacturing, but that is another story). Gantry Plaza State Park, on the East River, is a direct link to the industrial past. Along the way, notice exposed trolley tracks in unexpected places and see where they lead. The past will not remain buried forever.

Active customer-friendly businesses still abound. Whether these are fruit and vegetable stands, sidewalk cafés, or the local newspaper stand, each manages to keep loyal customers happy. This is the best anchor for a community, and all the neighborhoods that comprise Long Island City have managed to do this very well since their beginning.

One final note: one could become wistful over the scenes in this chapter. But mansions alone, however beautiful, do not a neighborhood make. Despite Long Island City's now-hectic and tenacious avenues, residents stick to the idea that people come first.

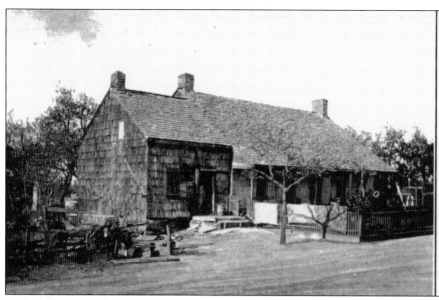

Gosman Farm House, Middleburg Ave., L. I. City 200 yrs. old. recently destroyed.

At the northeast corner of 39th Avenue and 45th Street, close to the present railroad embankment, stood the Bragaw-Gosman house and farm. This 200-year-old farmhouse stood on old Middleburg Avenue, a now vanished road that connected Woodside Avenue (originally a Native American path) to Newtown Village (Elmhurst) and Dutch Kills. It disappeared around 1925. A later Middleburg Avenue is now 39th Avenue in Sunnyside.

Boulevard Road to L. I. City L. Johnson Pub

The Boulevard (11th Street) is a wide street that ran the length of Long Island City from Hunters Point to Old Astoria. This segment, in Ravenswood, was last to develop. It was felt the nearby Sunswick Creek marsh (approximately 21st Street) was unsuitable for dwellings.

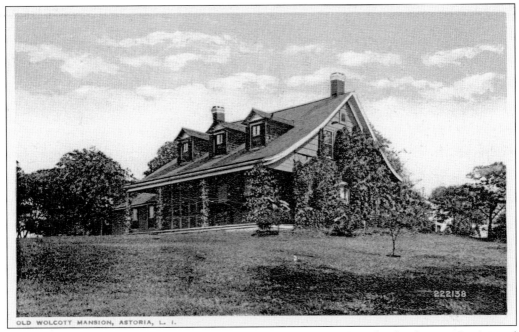

OLD WOLCOTT MANSION, ASTORIA, L. I.

This postcard is mislabeled as this is actually the Robertson-Trowbridge house. Quaint and homelike, this Colonial holdover was considered one of the most picturesque spots on the riverfront. The property was sold to the East River Gas Company and the house torn down about 1905. It was between 20th (Winthrop) and 21st (Wolcott) Avenues.

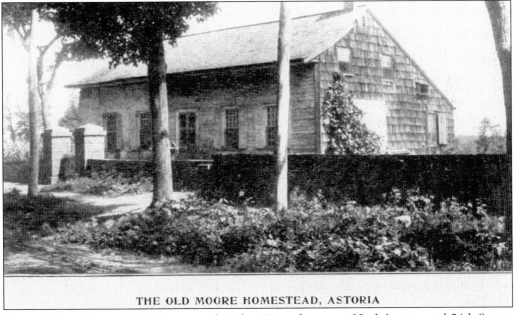

THE OLD MOORE HOMESTEAD, ASTORIA

Pictured is another mislabeled postcard as the Moore home, at 32nd Avenue and 54th Street, would be today described as Woodside, rather than Astoria. John Moore, who came to Queens in the 1650s, was called to be the first minister at the First Presbyterian Church of Newtown, the borough's oldest religious body. A landmark cemetery in Woodside and the legacy of a nephew, author Clement Clark Moore, remain.

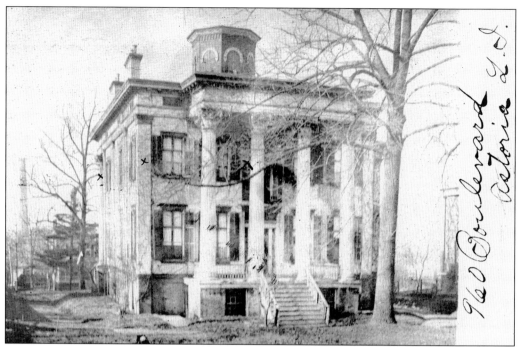

An observatory tower topped the LaRoque Mansion, a stone house with four towering columns in front and four in the rear. Merchant Horace Whittemore built it in the 1840s. The house passed to Joseph LaRoque, a lawyer and chief counsel for the Erie Railroad. This beautiful mansion in Old Astoria stood just north of 27th Avenue, mid-block between Fourth and Eighth Streets. It was destroyed in 1963.

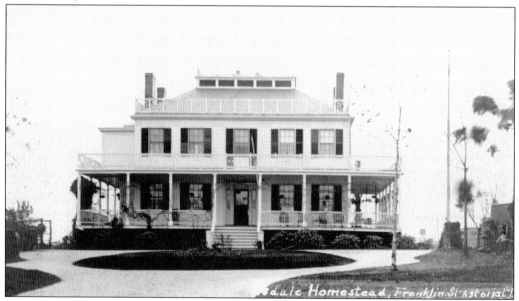

The Blackwell-Tisdale homestead, built in 1826, was modeled after the old planter's mansions of the antebellum South. Built on the highest point of "the Hill" in Old Astoria, it was the focal point of an immense sweeping view of the Hell Gate. Astoria Boulevard, 27th Avenue, Eighth Street, and Blackwell's Lane bound the estate. It is no longer standing.

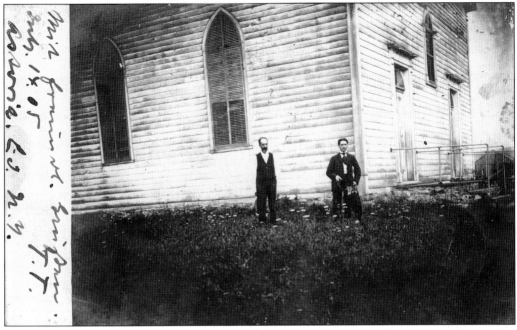

Two men are in a field next to a church at a forgotten moment at a location uncertain. This may be the First Reformed Church in Old Astoria Village. If so, these men are standing in its cemetery that holds the remains of many of the community's early prominent citizens, including Stephen Halsey, "the Father of Astoria."

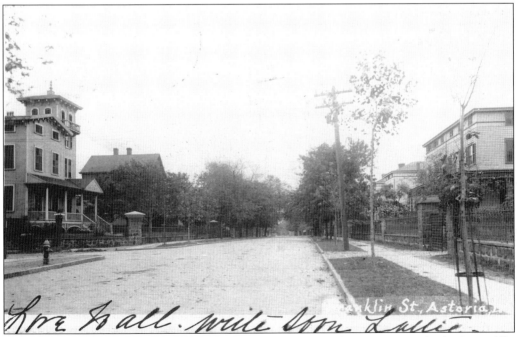

"Love to all, write soon, Lottie" the message implores a century after it was penned. This is Franklin Street (27th Avenue) and the top of "the Hill" in the heart of Old Astoria Village. It remains the most significant historic community in New York City with no official landmark protection.

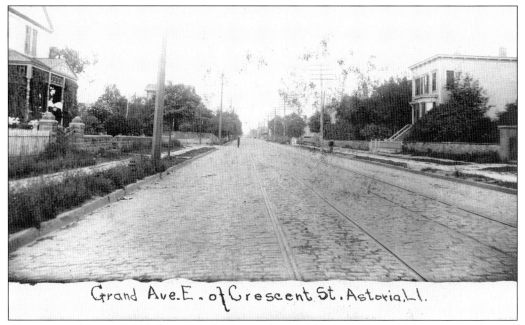

Grand Ave. E. of Crescent St. Astoria L.I.

The corner of Grand (30th) Avenue and Crescent Street (right) is today the Mount Sinai Hospital of Queens (formerly Astoria General Hospital). The trolley tracks, like the block's charm and quiet, are long gone.

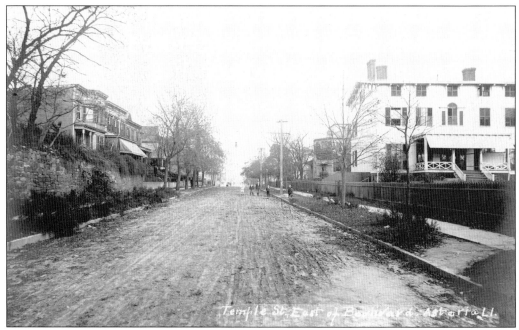

Temple St. East of Boulevard Astoria L.I.

Temple Street, now 30th Road, with its exceptional architecture remains one of the most stunning blocks in Old Astoria with an eclectic mix of homes. It is undoubtedly worthy of official landmark recognition.

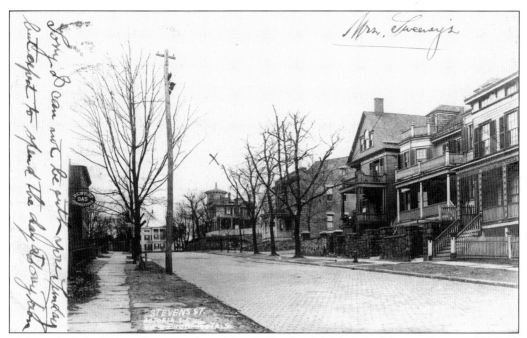

This card reads, "Tony I can not be with you Sunday." This is looking up Stevens (Eighth) Street in Old Astoria. Samuel Blackwell built the house at the corner (with the *x* above it) for his daughter who married Charles Burr, a merchant. In 1866, Gen. Thomas William Sweeney, a veteran of the Mexican and Civil Wars, rented the house. Everything to the left of this image is now part of the Astoria Houses.

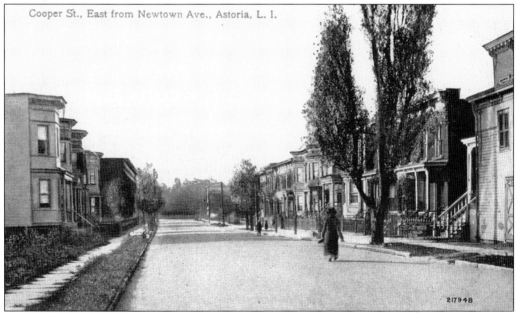

Postcards captured everything from elegant mansions to homes of workers and shopkeepers. Cooper Street is today 27th Street between Newtown Avenue and Grand (30th) Avenue. This area is zoned for heavy development today, and pockets of charming homes, as these, are endangered.

35

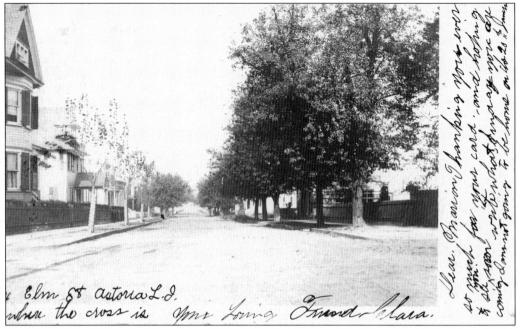

Elm Street (30th Drive) was lined on one side with elm trees. On this block, a large mansion, called Mount Napoleon, was the home of Revolutionary War general Ebenezer Stevens, a grandfather of Edith Wharton. For the first half of the 19th century, his home played host to the political and cultural elite of that era. As a young man, Stevens participated in the Boston Tea Party.

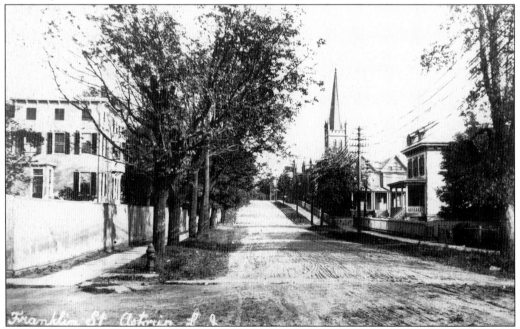

This is a marvelous picture of the great sweep up 27th Avenue to the crest of "the Hill" in Old Astoria. To the right is the First Presbyterian Church from the 1840s. By 1950, everything on the right of the street became part of the Astoria Houses.

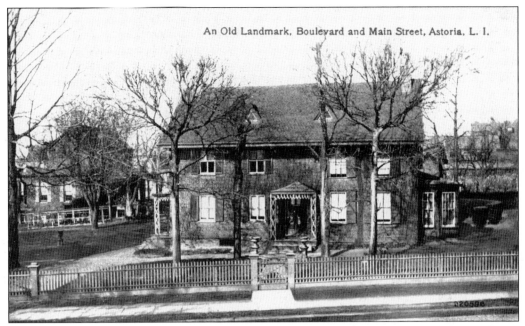

An Old Landmark, Boulevard and Main Street, Astoria, L. I.

A charming country house, built about 1840 near the site of William Hallett's farm, was home to John Trafford, one of the early settlers at Hallets Cove. One legend states that it became a tavern frequented by mariners forced to wait for favorable tides at the Hell Gate. The house was gone by the 1920s, and this is today Hallets Cove Playground.

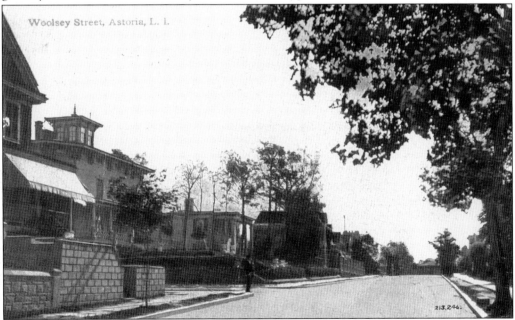

Woolsey Street, Astoria, L. I.

Woolsey (14th) Street was named after Edward Woolsey, the owner of the 400-acre Casina Farm, an estate assembled by his family in the late 18th century (on land that is now the Poletti Power Plant). Most homes pictured are still standing, including the Trowbridge-Stratton mansion (1852) and the adjoining Graham mansion. Sitting on large plots of land encourage developers to pressure home owners to sell.

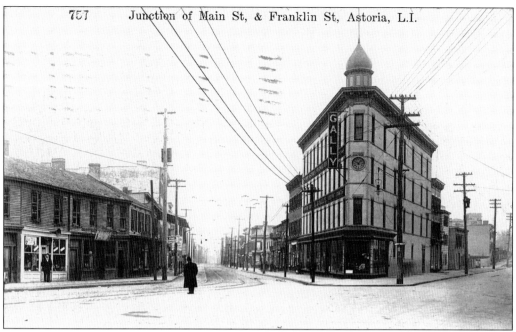

Looking west from 21st Street, the "Astoria Flatiron" building still commands the intersection of Franklin Street (27th Avenue), and Main Avenue. This bustling junction of five roads is known as Astoria Square. The flagpole on the cupola, after being hit by lightning, was removed a few years ago.

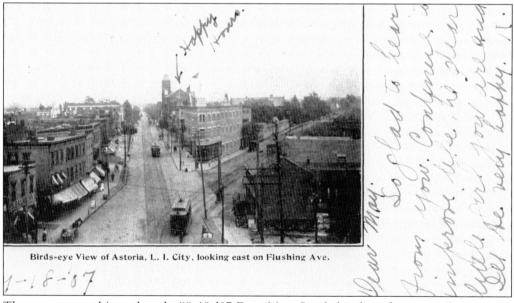

Birds-eye View of Astoria, L. I. City, looking east on Flushing Ave.

The message on this card reads, "9-18-'07 Dear May: So glad to hear from you. Continue to improve like the dear little girl you are and I'll be very happy. R." See pages 39 and 78 for other perspectives of these buildings at Newtown Avenue and Astoria Boulevard. Perhaps this picture was taken from the cupola of the "Astoria Flatiron" building. The Mount Carmel School's mansard tower is in the distance.

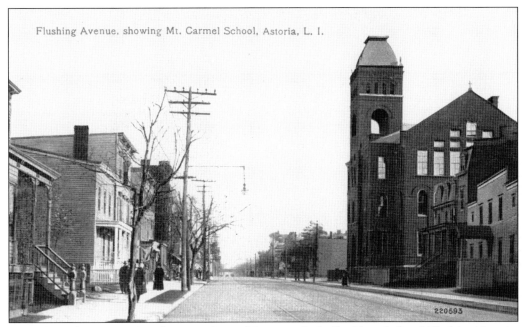

The school for Our Lady of Mount Carmel Roman Catholic Church faced Flushing Avenue (Astoria Boulevard). Although the school expanded over the years, declining attendance forced it to recently close. The residence at the right is the convent of the Sisters of St. Joseph, who taught at the school.

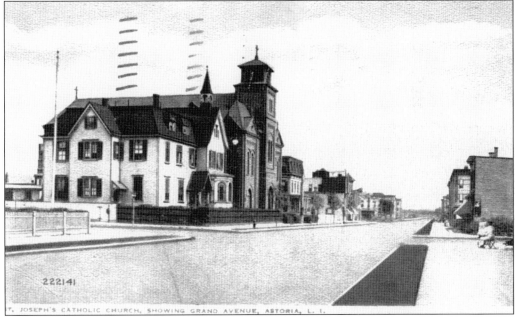

The near doubling of Long Island City's population, especially after 1890, greatly stimulated the building of churches and the founding of new congregations. St. Joseph's German Catholic Church was built in 1878 on the north side of 30th Avenue between 43rd and 44th Streets. The parish was in the midst of the rapidly developing "German Settlement," as east Astoria was then called.

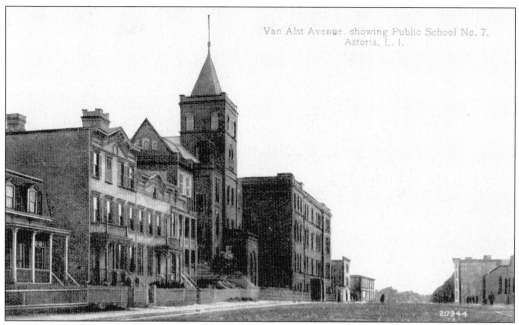

Public School 7 was on the east side of 21st Street (Van Alst Avenue) almost opposite 26th Road. The three-and-a-half-story brick building was built in 1901, although the site was acquired in 1886. In 1908, a large addition was added on the south side, almost doubling the capacity. The school burned down a few decades ago.

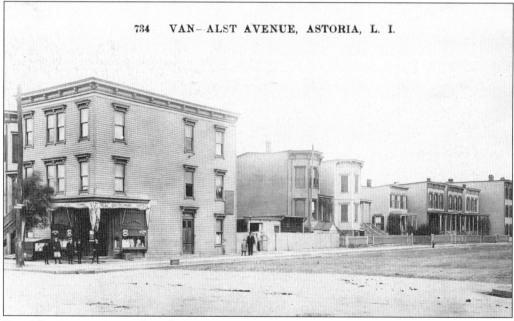

Van Alst Avenue, originally called Emerald Street and later 21st Street, eventually was opened through to Hunters Point. South of this view the street bed became uneven, having been built on top of a swamp, Sunswick Creek. The marshy ground was filled with ashes and industrial waste and its unstable terrain was not considered a good place for building. The exact location of this postcard is uncertain.

This is another mislabeled card. "Shore Road" seems to be 19th Road, a Native American trail that ran along the shore of northern Astoria through the Steinway section. To the right may be the landmarked Lawrence family cemetery.

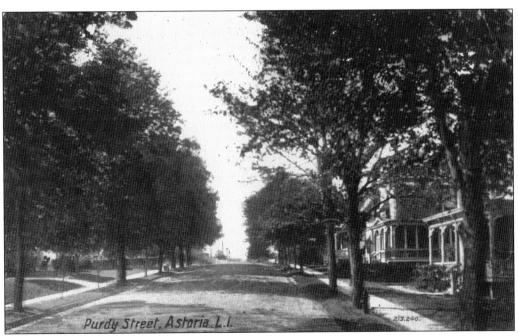

This is a beautiful postcard looking up elegant Purdy (43rd) Street near the Steinway piano factory. One of the managers at the Steinway piano factory lived in the graceful house on the right.

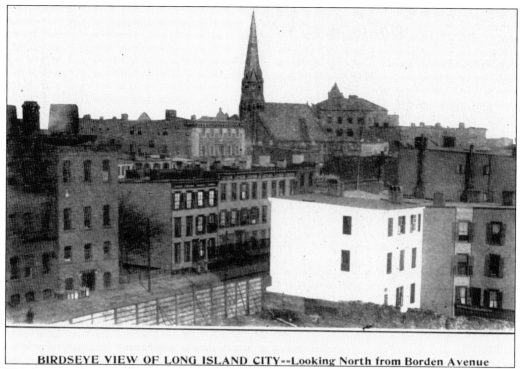

BIRDSEYE VIEW OF LONG ISLAND CITY--Looking North from Borden Avenue

This is a rare photograph postcard of Hunters Point, the industrial and commercial heart of Long Island City. The steeple of St. Mary's Church and school command the image center. Borden Avenue ran along the rail yards. This was perhaps taken from the roof of the ferry terminal.

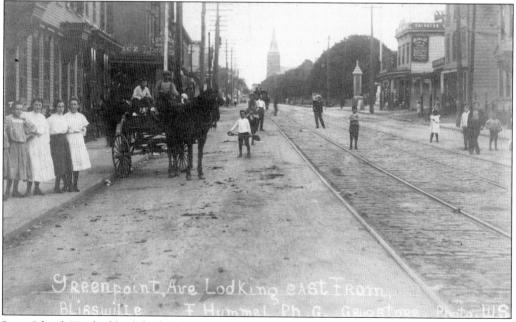

Long Island City had both leafy suburban settings, as Purdy Street, and more gritty urban blocks, as Greenpoint Avenue, the main street of Blissville near Newtown Creek. In the distance are Calvary Cemetery and the steeple of St. Raphael's Roman Catholic Church.

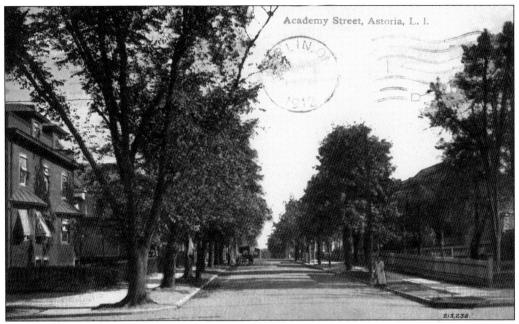

The postal cancellation stamp from 1912 does not detract from the beautiful homes on Academy (29th) Street. A delightful mix of homes and greenery on a nearly empty street gives the sense of a graceful time gone by. The building on the left is still at 31st Avenue and 29th Street behind the Astoria Medical Group.

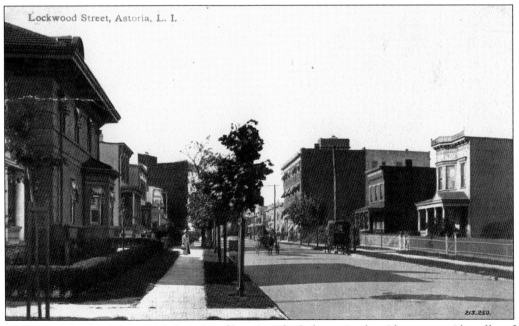

Lockwood (30th) Street, with its mix of housing, had charm in the tidy streets, sidewalks of bluestone, and newly planted trees. Unlike some modern development, no building is out of scale on this block.

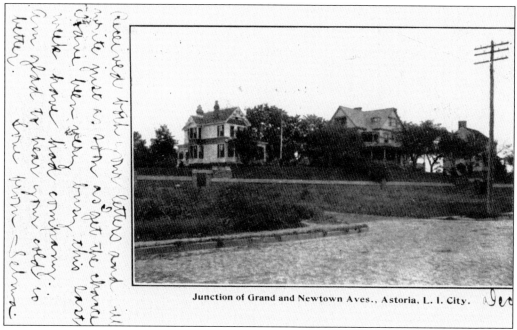

Junction of Grand and Newtown Aves., Astoria, L. I. City.

"Received both your letters and will write just as soon as I get the chance. Have been very busy this last week have had company. Am glad to hear your cold is better. Love from Selma." At the location of former plant nurseries, this is the junction of Grand (30th) and Newtown Avenues. The triangle where the streets meet was called Briell Park. One house remains.

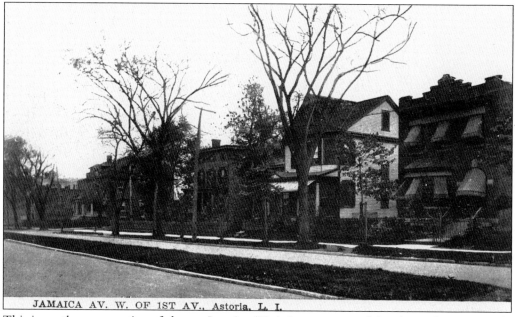

JAMAICA AV. W. OF 1ST AV., Astoria, L. I.

This is another perspective of elegant Jamaica (31st) Avenue west of the elevated train. Nearly all these homes were replaced with apartment buildings. The median down the middle of the avenue adds a touch of elegance.

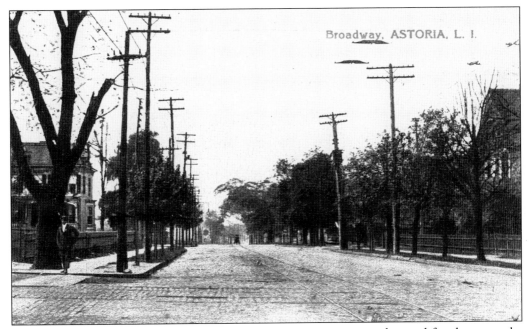

Broadway, ASTORIA, L. I.

A major trolley line, Broadway was always an important east–west thoroughfare between the East River and the city limits at Newtown Road and 51st Street. Looking west from 31st Street, Broadway retained its residential character throughout the 19th century. It showed little traffic despite being a transportation artery.

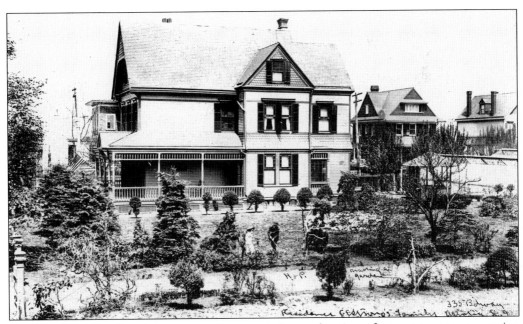

Spacious homes and well-kept grounds were a clear indication of a prosperous community. This home was between 30th and 31st Streets on the north side of Broadway. It was replaced by denser development in the 1920s.

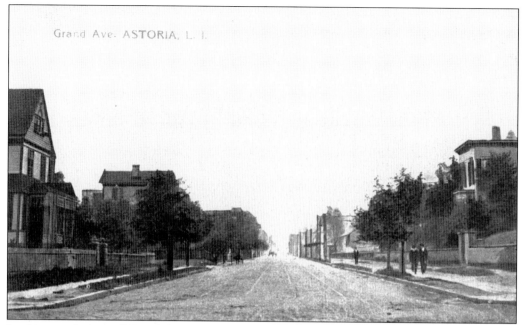

In this grand view of Grand Avenue yet another sweep of beautiful houses and properties on one of Astoria's finest streets can be seen. It is a classic picture of the community from about 100 years ago.

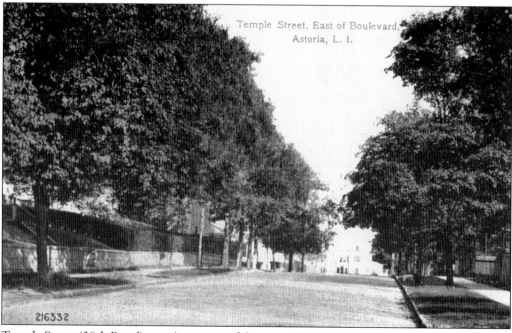

Temple Street (30th Road) remains as one of the most charming blocks in the community. This view is facing east, with Vernon Boulevard and the East River to the back.

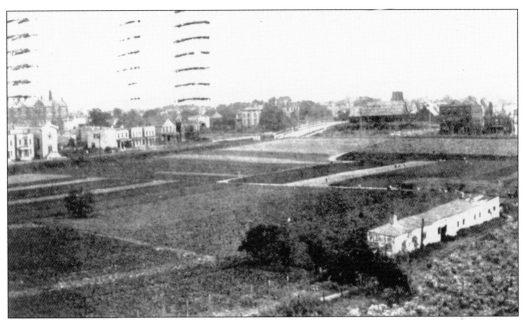

This rare view shows some of the community's famed farms and gardens soon to be obliterated. A wave of development followed after the Queensboro Bridge (1909) and the elevated trains (1917) opened for service. The view is from 21st Street southeast toward the Church of the Redeemer on Crescent Street. Congregation Mishkan Israel, to the left, dates this picture sometime after its founding in 1904.

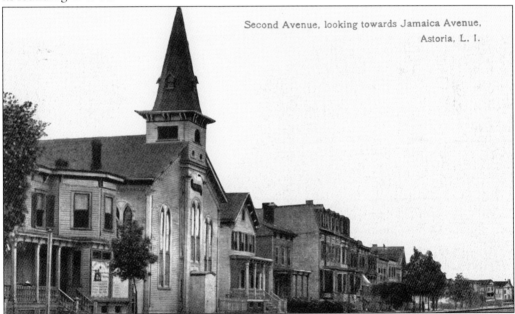

Second Avenue, looking towards Jamaica Avenue, Astoria, L. I.

This is at 31st Street (called Second Avenue in the card) between 30th and 31st Avenues, looking south. The elevated line today runs right down the middle of the street. The Second German Reformed Protestant Church is gone, but the building, erected in 1867, remains. The mansard buildings in the background were destroyed by fire in the 1990s. The building is now a Taiwanese church.

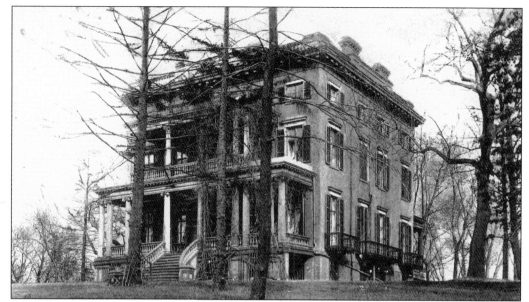

The Barclay Mansion, south of Ditmars Boulevard on Shore Road, was built about 1840. It was torn down in 1914 to make room for the Queens tower of the Hell Gate Bridge. Col. Henry Barclay, whose father, Thomas, was appointed British consul general after the War of 1812, built a successful insurance business as representatives for Lloyd's of London. This was his mansion.

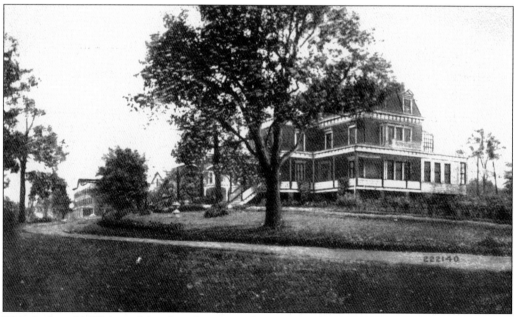

This is the old Wolcott Mansion, between Crescent and Kindred (27th) Streets. Dr. John Kindred turned it into the private sanitarium River Crest. For a few decades before the land was developed in the 1920s, this suburban retreat catered to nervous diseases, alcoholism, and drug addiction. See also page 88.

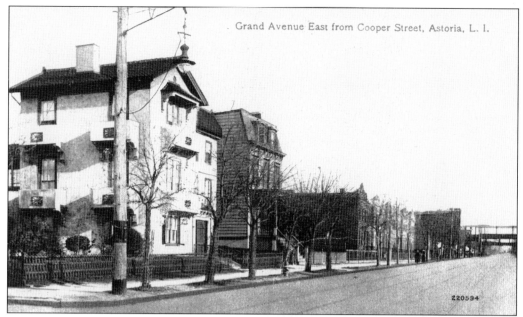

Grand (30th) Avenue facing east from Cooper (27th) Street retains its sleepy charm on a wintry day just after the elevated trains opened in 1917. Opening the community to mass transportation is about to augur a big change. Soon this block would be mostly lined with apartment houses. The white building to the left is still there.

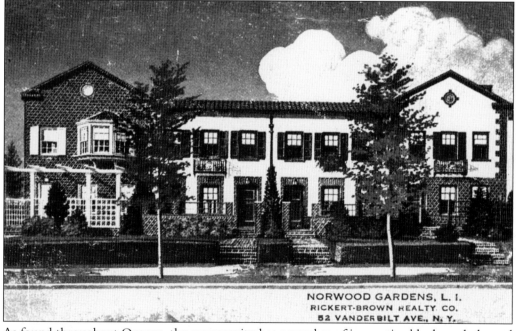

NORWOOD GARDENS, L. I.
RICKERT-BROWN REALTY CO.
52 VANDERBILT AVE., N. Y.

As found throughout Queens, the community has a number of innovative blocks and planned communities, a legacy of the Progressive Era. Norwood Gardens, from the early 1920s, has deep front yards with a variety of evergreens and flourishing shrubs. A pleasing contrast of red brick and white stucco accentuated by iron balconies and lattice work make 36th Street between 30th Avenue and 31st Avenue a delight. This is a landmark-worthy community.

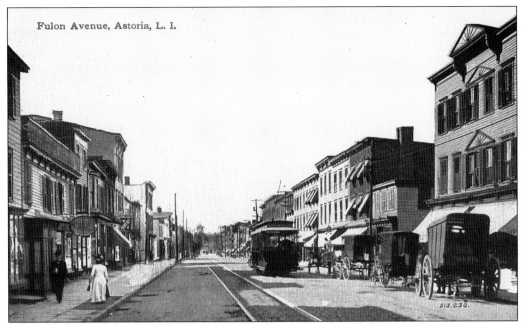

Fulon Avenue, Astoria, L. I.

213.230.

One of the original streets in Old Astoria dating from 1842, Fulton Street was the main shopping street of the community. It started at the ferry, ran through the heart of Old Astoria, then on to Flushing. Today it is known as Astoria Boulevard.

Broadway and Steinway Avenue, Astoria, L. I., N. Y. 502

The trolley and its tracks may be long gone, but this view west down Broadway from Steinway Street has changed little in 80 years. The brick building on the left, built in 1919, was owned by a number of banks: Corn Exchange, Manufacturers Hanover, Chemical, and finally JPMorgan Chase. See the trolley on the left? The elevated train on 31st Street is in the distant background.

When the elevated train started service in 1917, these buildings went up almost overnight. Except for the change of store names, this view remains essentially unchanged to this day. The large building in the distance, the Broadway Theatre, closed its doors decades ago. The building is still used for a variety of purposes. Fink's Ice Cream Parlor (right) is between 32nd and 33rd Streets under the soda sign.

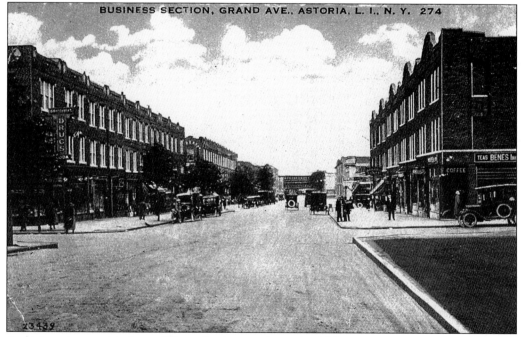

At each station on the elevated line, a business community of shops, restaurants, and stores sprang up. Like the neighboring elevated stop on Broadway, shown above, lightly settled Grand (30th) Avenue became a thriving community overnight. This view faces west.

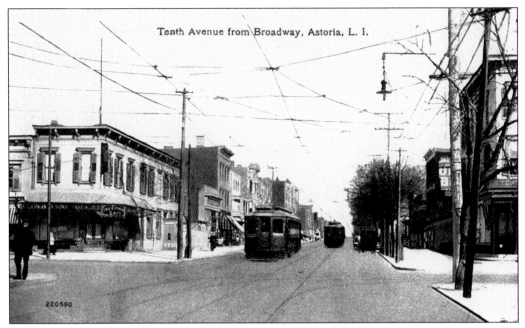

Tenth Avenue from Broadway, Astoria, L. I.

This view was taken looking north up Steinway Street (formerly 10th Avenue) from just west of Broadway. Often called the longest outdoor shopping mall in the world, the street has remained the central shopping district for Astoria and Steinway for nearly 150 years. Note the street trolleys (at one time owned by the Steinways) and the labyrinth of overhead wires.

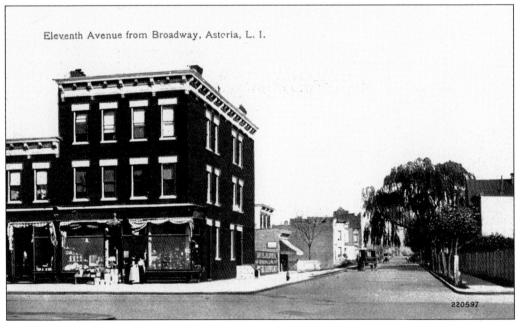

Eleventh Avenue from Broadway, Astoria, L. I.

Eleventh Avenue or Albert Street, and now 41st Street, may have gone through name changes, but the buildings have remained essentially unchanged. This property was featured in the opening credits of *Archie's Place* as the location of his bar. Of course, the only connection that Archie Bunker has with Astoria was in the imagination of his creator, Norman Lear.

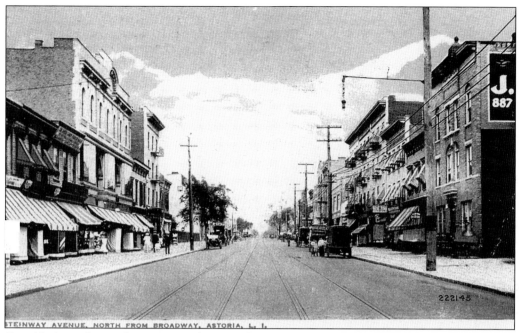

STEINWAY AVENUE, NORTH FROM BROADWAY, ASTORIA, L. I.

Considering at least a dozen postcard views of Steinway Street exist, it is correct to assume it was (and remains) an important retail district. This is a view on that street north from Broadway. An old advertising slogan boasted, "Shop Steinway and Save!"

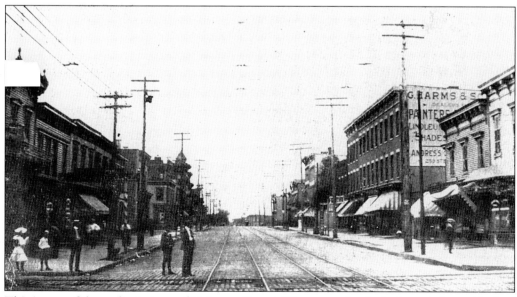

This is one of the earliest views of Steinway Street. The network of telephone poles and lack of traffic would date this picture no later than 1900.

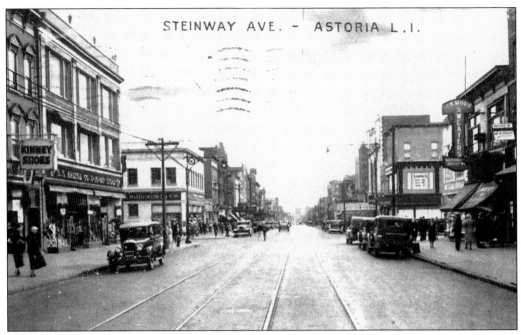

STEINWAY AVE. - ASTORIA L.I.

Remove the trolley tracks and telephone poles, change the names of the stores, and this intersection of 31st (Jamaica) Avenue and Steinway Street remains unchanged from the 1920s. On the left are Kresge's and Woolworth's five-and-dime stores. This view looks south.

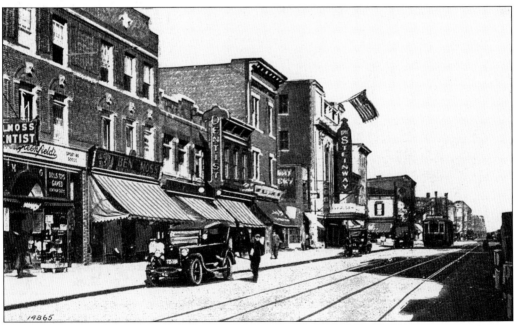

Here is yet another view looking north along Steinway Street around 1925. The Steinway Theater, formerly Horack's Opera House, is on the left near 31st (Jamaica) Avenue. The building is still there but is given over to commercial purposes.

54

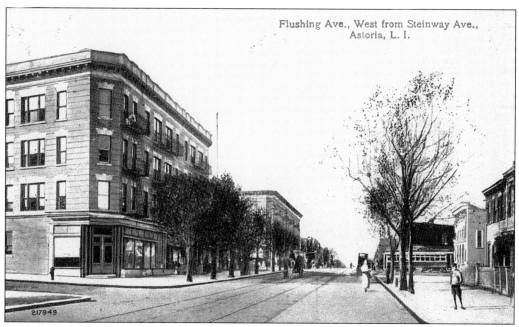

This view west of the corner of Flushing Avenue (today Astoria Boulevard) and Steinway Avenue was changed in the 1930s when the roadway from the Triborough Bridge sliced a large trench through the community. The six-lane highway led to the Grand Central Parkway and on to Robert Moses's Long Island parkway system. Every building on this postcard is gone.

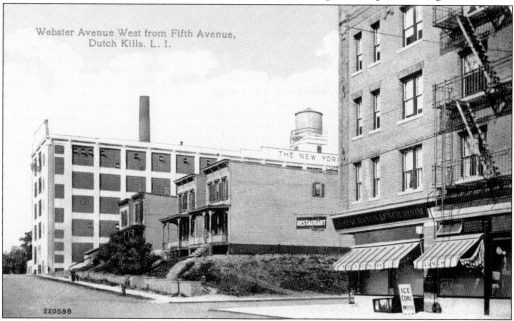

The corner of Webster (37th) Avenue and Fifth Avenue (34th Street) shows the community of Dutch Kills in transition. The loft building and new apartment went up shortly after the elevated train began service (1917) three blocks away on 31st Street. The middle clutch of buildings, built before the street was graded, dates from the rural past. Ethel Merman (1908–1984) grew up in this neighborhood.

Sunnyside, formerly Blissville, was the last district developed in Long Island City. Sunnyside Gardens is widely considered one of the most successful examples of planned communities anywhere. It is on the National Register of Historic Places and is designated as an official New York City landmark district.

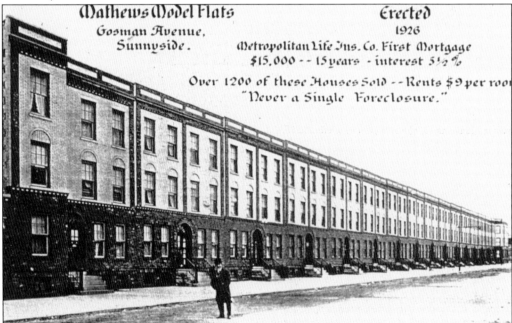

Mathews Model Flats Erected
Gosman Avenue, 1926
Sunnyside. Metropolitan Life Ins. Co. First Mortgage
 $15,000 - - 15 years - interest 5½ %

 Over 1200 of these Houses Sold - - Rents $9 per roo[m]
 "Never a Single Foreclosure."

The G. X. Mathews Company, one of the most successful builders in Queens, used clever advertising through postcards. This is a Mathews Model Flats advertisement from the mid-1920s for a new development on Gosman Avenue (48th Street) in Sunnyside. In the picture is Albert Mathews, a brother who handled the advertising.

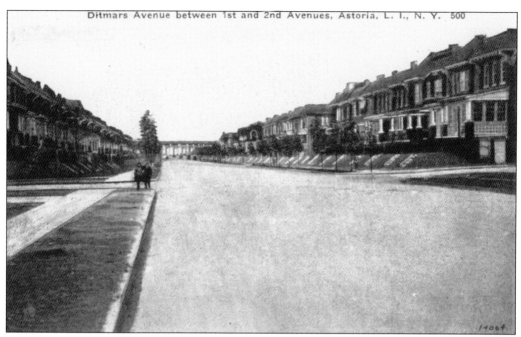

This is Ditmars Boulevard west of First Avenue (30th Street). The Hell Gate Bridge viaduct on Wards Island is in the distance. The Rickert-Brown Company, large development pioneers, bought some 2,000 lots in the Ditmars area. In 1921 and 1922, it built and sold over 100 single-family brick houses of six rooms each on Ditmars Avenue.

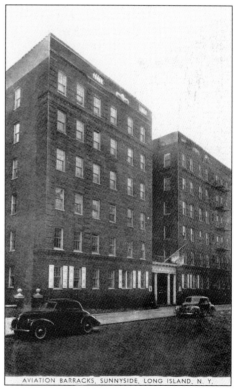

AVIATION BARRACKS, SUNNYSIDE, LONG ISLAND, N. Y.

During World War II, the aviation barracks in Sunnyside housed military personnel who worked stateside at military facilities in the area. Soldiers worked at the massive military mail distribution center (the world's largest) on Northern Boulevard and 48th Street and at the U.S. Army Pictorial Center at the Astoria Studios.

57

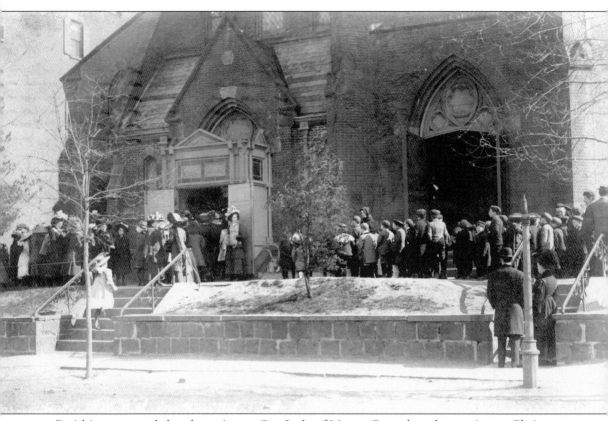

Parishioners attend church services at Our Lady of Mount Carmel, perhaps going to Christmas services, around 1910. The social life of many residents, both native-born and immigrant, revolved around church congregations.

Three

HOUSES OF WORSHIP

Religious worship was always a cohesive force throughout the community. Irrespective of denomination, houses of worship dotted the early landscape, each splendid in its own way, all sharing in the overall importance of devotion to God. They also served as necessary social outlets for their congregants (for some the only social outlet), who after services would catch up with one another. And as for the young, religious service and/or Sunday school helped reinforce the values their parents held dear.

In the early years of Long Island City, Protestant, Catholic, and Jewish denominations peaceably tended to the spiritual needs of their respective congregations. Yet the small, almost hometown setting in which they were in added a special dimension to the piety of each; for in such a setting, how could it not be easy for worshippers to come together in the spirit of true fellowship?

That lofty feeling has been a constant as Long Island City has become more ethnically diverse over time. Such an experience has actually broadened the scope of religious awareness in Long Island City, enriching its meaning and vitality. Catholic churches have expanded to include Hispanic and Croatian congregations. Worthy of note is an emerging Islamic influence in the area with its growing number of mosques that first appeared only recently. Represented also are Korean Methodists and Jehovah's Witnesses. Not to be excluded is the robust presence of Greek Orthodox worshippers in the area, whose Byzantine churches are filled with lit candles, icons, and incense. Their Good Friday processions and joyous Easter celebrations have become annual features on the local scene.

The prevalence of religious freedom is essential to understanding Long Island City itself. It would certainly account for much of the ardor its population has for the place it calls home.

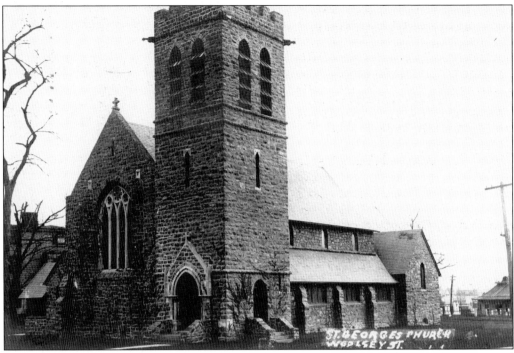

St. George's Episcopal Church started on the northeast corner of Woolsey (14th) Street and Astoria Boulevard in 1825 when Samuel Blackwell donated land. A wooden frame church in the form of a Greek temple was finished in 1828 and was used until January 1894 when it burned down. The new church (pictured) was begun in July 1903, this time facing 27th Avenue. It was dedicated in February 1904.

The First Reformed Church of Astoria, on Remsen (12th) Street, was organized in 1835. The present building, dating from 1889, is described as Victorian Gothic, with terra-cotta, brick, and copper details. It lost its first steeple after being hit by lightning. Behind the church are gravestones from its lost cemetery bearing inscriptions for Stephen Halsey, the founder of Astoria Village, and Grant Thorburn, its first postmaster. See also page 31.

This view is up 27th Avenue toward "the Hill" in Old Astoria and the First Presbyterian Church of Astoria. Its cornerstone was laid on November 30, 1846. In April 1922, the congregation sold this building and moved to a new location on the west side of 33rd Street between Broadway and 31st Avenue. The old church on this card is long gone, and the block is part of the Astoria Houses.

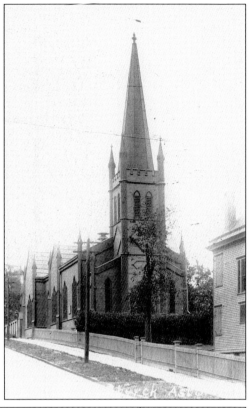

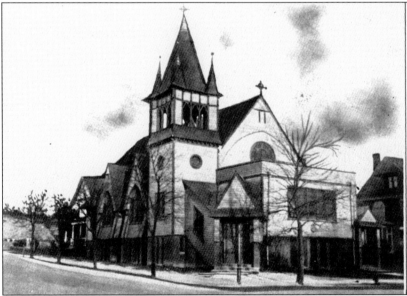

Steinway Reformed Church, Ditmars Ave. Cor. Ninth Ave. Long Island City.

Steinway Reformed Church on Ditmars Avenue and Ninth Avenue is incorrect. The church was actually at 11th Avenue (41st Street). The congregation, which began in 1879, outgrew its first building and moved to the present location in 1891. William Steinway contributed a pipe organ from Steinway Hall. Some researchers believe the building was ordered from a mail-order catalog.

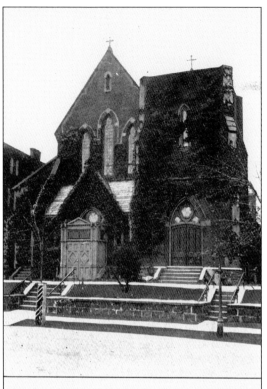

Lady of Mt. Carmel, Flushing Ave. and Newton Road, Astoria

Organized in 1841, Our Lady of Mount Carmel was one of the first Roman Catholic parishes in Queens. The congregation, then called St. John's, used a small building at 26th Avenue and 21st Street. When it outgrew that building, a larger facility went up at Newtown Avenue and Crescent Street. It was dedicated on August 17, 1873. The older location, on 21st Street, remains a parish cemetery.

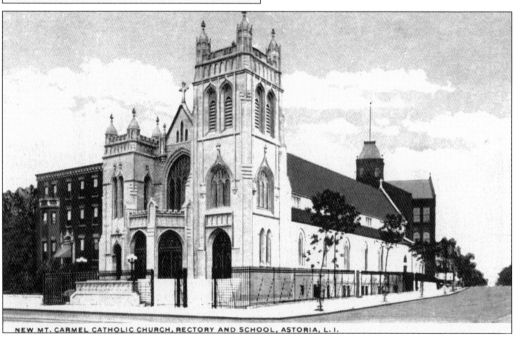

NEW MT. CARMEL CATHOLIC CHURCH, RECTORY AND SCHOOL, ASTORIA, L. I.

Between 1897 and 1930, the church membership increased from 2,500 to 6,000, forcing Our Lady of Mount Carmel to expand. This is the modern church facade (1915) with a completed bell tower and handsome stonework. The building in the background is the former parish school.

The German Lutheran Church, organized in 1890, was a wooden frame Gothic church seating 700. It was built mid-block on 37th Street near 31st Avenue. The cornerstone was laid on May 4, 1890. The steeple was hit by lightning twice in 1920: on June 29 and two weeks later on July 14.

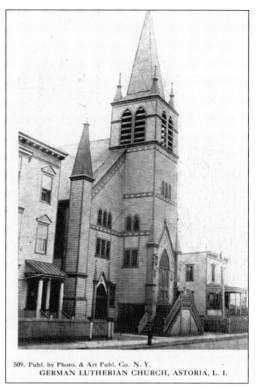

509. Publ. by Photo. & Art Publ. Co. N. Y.
GERMAN LUTHERIAN CHURCH, ASTORIA, L. I.

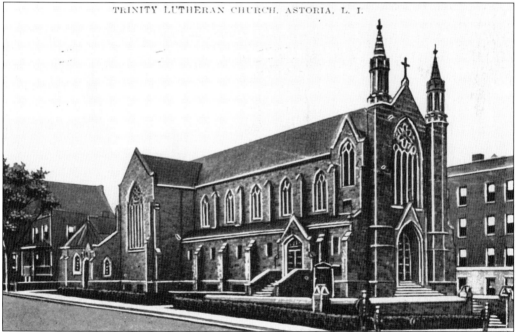

TRINITY LUTHERAN CHURCH. ASTORIA, L. I.

Trinity Lutheran Church outgrew its frame building by the end of World War I and in 1927 erected a handsome new granite edifice in the English Gothic style at the corner of 37th Street and 31st Avenue. The new church opened for worship in November 1927. In 2006, the east tower was hit by lightning.

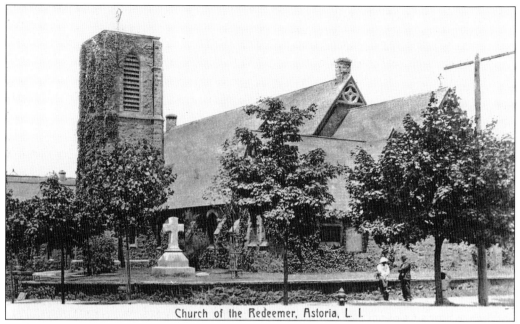

Church of the Redeemer, Astoria, L. I.

The Church of the Redeemer was organized on August 19, 1866. The bell tower and dark brooding edifice of ashlar granite, as described by architects, was opened for worship services in 1868. Strangely it was not consecrated until 1879. The Redeemer Episcopal congregation remains at 30th Road and Crescent Street to this day.

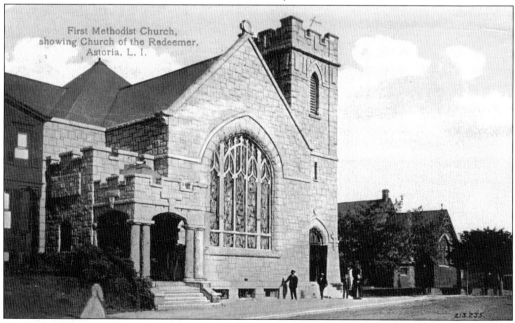

First Methodist Church, showing Church of the Redeemer, Astoria, L. I.

The First Methodist Episcopal Church (1824) is the oldest congregation in Long Island City. Its first church (1844) was on Main Avenue in Old Astoria; it moved to 21st Street in 1886 and finally in 1908 to the southwest corner of Crescent Street and 30th Road. All three buildings are still standing. It was called Trinity Methodist and First Methodist before settling on its current name, Good Shepherd United Methodist Church.

A boom in church building followed the Civil War. The Second Reformed German Protestant Church, organized in 1854, was able to raise enough money to finally erect a church in 1867. It was enlarged in 1889. From its inception until 1922, Rev. Charles Steinfuher held sway from its pulpit. Although the congregation has changed, the church still stands on 31st Street (Second Avenue on the card) near 31st Avenue.

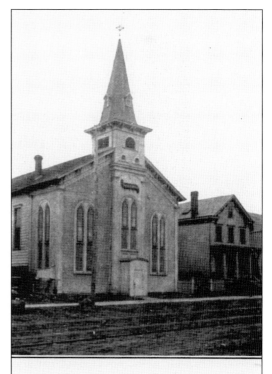

German 2d Reformed Church, 2d Ave., L. I. City.

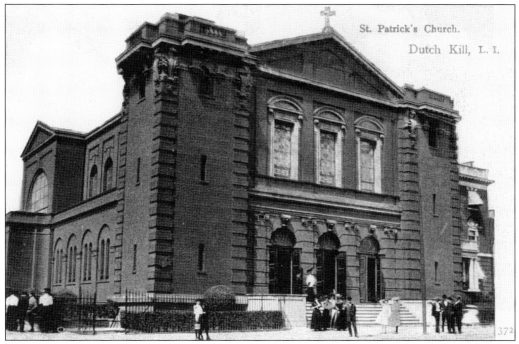

St. Patrick's Church.
Dutch Kill, L. I.

Starting as a small congregation in 1869, St. Patrick's Church in Dutch Kills moved to the present location on 29th Street and 40th Avenue about 1898. The new church is brick with terra-cotta trimming. The towers were never completed.

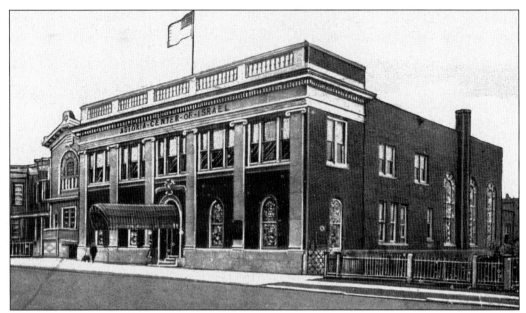

Located on Crescent Street at 29th Avenue, the Astoria Center of Israel opened its doors in 1926. Its cornerstone bears the dates 1925/5686. The Astoria Center was built when space became inadequate at the Congregation Mishkan Israel. The smaller synagogue (pictured to the left of the larger building) was the third-oldest temple in Queens (1904). See page 47 for an earlier aerial view of this block.

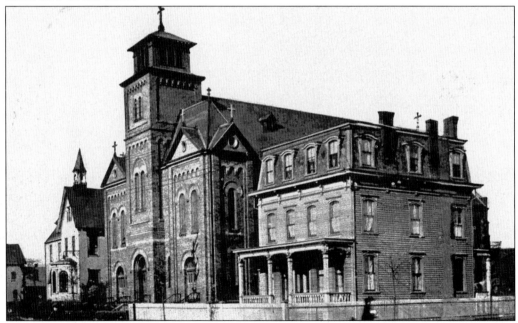

St. Joseph's German Catholic Church was organized in 1877. It began as a wooden frame church, completed in 1880, on 30th (Grand) Avenue between 43rd and 44th Streets. Several capital campaigns over time built up an adjoining parish school, rectory, and convent. The old rectory, the smaller mansard building on the right, was moved in the 1920s to 47th Street and Newtown Road.

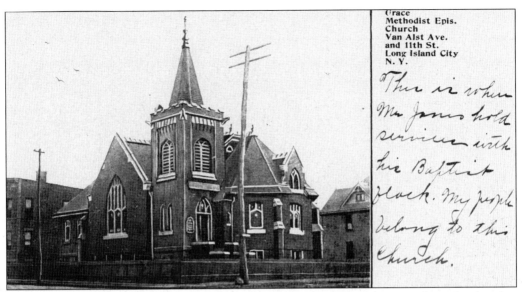

Grace Methodist Episcopal Church
Van Alst Ave.
and 11th St.
Long Island City
N. Y.

This is where Mr. Jones hold services with his Baptist flock. My people belong to this Church.

Grace Methodist Episcopal Church began as a Sunday school mission sent from Greenpoint, Brooklyn, in 1860. Organized in 1863, the congregation built the current building on the southeast corner of 21st Street and 45th Road in 1900. The message on the card states, "This is where Mr. Jones hold[s] services with his Baptist flock. My people belong to this church." The building still stands although the congregation has changed.

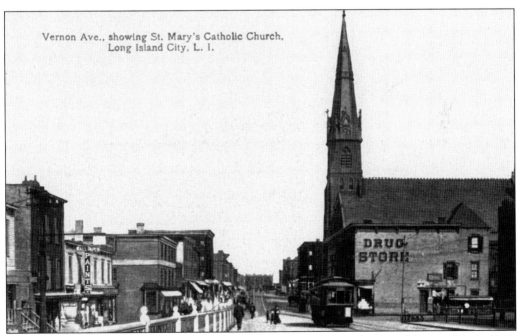

Vernon Ave., showing St. Mary's Catholic Church,
Long Island City, L. I.

Organized on August 26, 1865, St. Mary's Roman Catholic Church opened for worship in 1869. A new building was begun in July 1887 at the southeast corner of Vernon and 49th Avenues. After that building was destroyed in a spectacular fire, the present church was erected on the same site in 1894. The first pastor, Fr. John Crimmins, was one of the driving forces behind the creation of Long Island City.

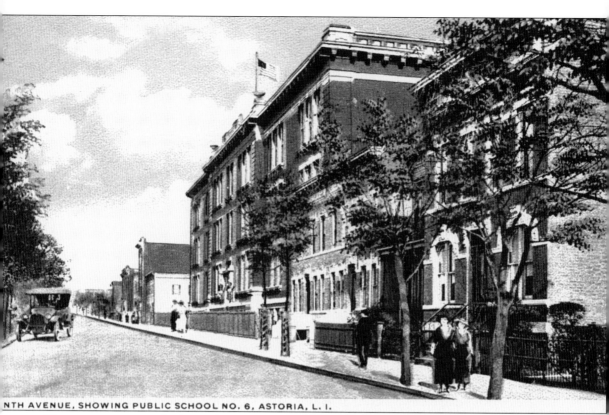

NTH AVENUE, SHOWING PUBLIC SCHOOL NO. 6, ASTORIA, L. I.

The cornerstone was laid on Thanksgiving Day 1885 for the Fourth Ward Primary School. It was later called Public School 6. The original section was a one-story brick building with 12 classrooms. The portion facing Steinway Street became a parking lot, and the back, facing 38th Street (this view), became a park named Sean's Place.

Four

SCHOOLS

One of Long Island City's undertakings shortly after its incorporation in 1870 was to institute a board of education, which took charge and hired the necessary number of qualified teachers, revised existing curricula, and built new schools. Nearly three decades later, the school system was comprised of five wards, and as many as 10 schools were already built to provide for the ongoing educational needs of children.

Today it is easy to see how seriously the community leaders took to the task of educating children by admiring the architecture of its early schools. Stately and imposing school buildings were true bulwarks of the city, symbolic of the overarching principle that the welfare of citizens depended on investing in the future.

Schools ran by a rational framework inspired by the Industrial Revolution. Student classes were divided into grades, with the student ages being the determining factor, which were then instructed accordingly. (The number of students of similar age determined how many classes were within each grade.) Even so was the layout of what is thought of today as the traditional classroom, with rows of students dutifully sitting at their desks facing their teacher who proceeded with the lessons of the day, carefully timed and paced. A classroom would be remiss if it did not have the teacher's cursive script stating a moral truism on the blackboard and, of course, an American flag prominently displayed.

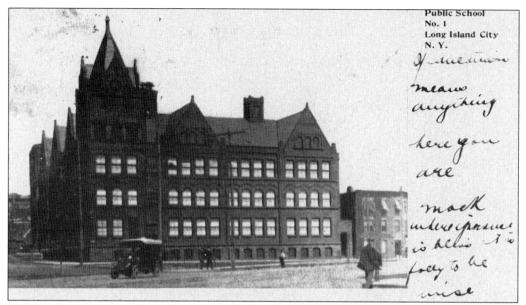

"If education means anything here you are Mack, where ignorance is bliss it's folly to be wise." The First Ward Primary School (Public School 1), at 21st Street and 46th Road, was the largest grammar school on Long Island when built in 1892. In 1962, the school was closed. In June 1976, the school was converted into an art space called P.S. 1 Contemporary Art Center.

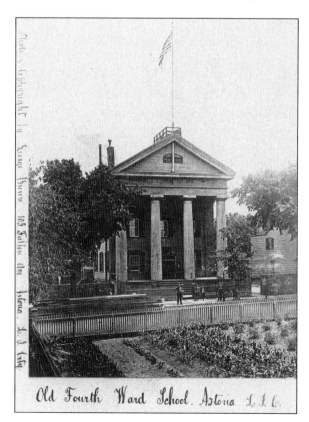

Old Fourth Ward School. Astoria L.I.C.

In 1849, Stephen Halsey donated a plot of ground slated for a public school. The old Fourth Ward Grammar School, built in the Greek Revival style with four Doric columns, occupied a location on Academy (29th) Street, just south of Grand (30th) Avenue from 1851. It was one of the first schoolhouses in Astoria. It was torn down for a new Public School 5 in 1904.

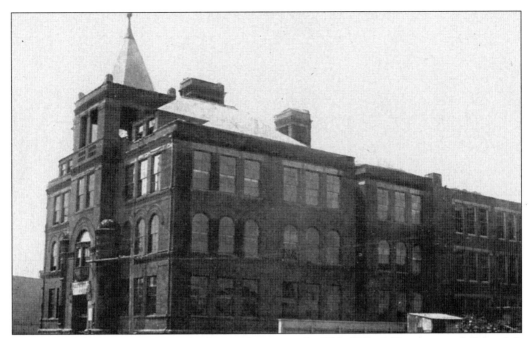

When opened in 1886, Public School 4 was known as the Third Ward (Ravenswood) School. It stood on Prospect (27th) Street between 39th and 40th Avenues. It was later expanded through to Crescent Street. From the 1950s to the 1980s, this building was the Long Island City High School Annex. Although the 27th Street section was torn down for the Evangel Church, the back portion remains as the church's school.

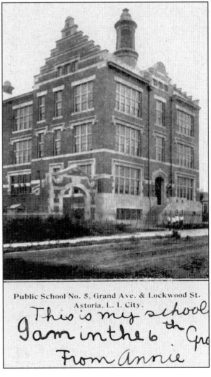

Public School No. 5, Grand Ave. & Lockwood St.
Astoria, L. I. City.

This is my school I am in the 6 th Gr From Annie

Annie writes, "This is my school. I am in the 6th Grade." Also known as the new Fourth Ward School, Public School 5, near Grand Avenue and Lockwood Street (30th Avenue and 30th Street), was built after the old school was torn down in 1904. At this location, several schools, Intermediate School 235 and Public School 234, now serve the community. See page 72 for an earlier school on the same site.

73

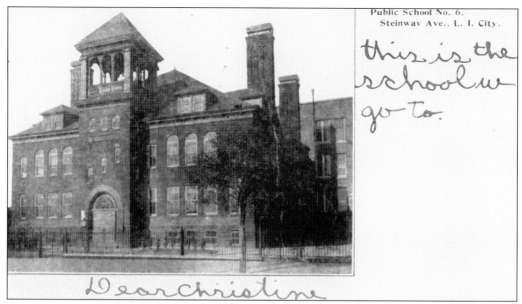

this is the
school we
go to.

Dear Christine

"Dear Christine / this is the school we go to," writes a student in 1910. Public School 6 was located on Steinway Street between Broadway and Jamaica (31st) Avenue. See page 70 for a back view of the school.

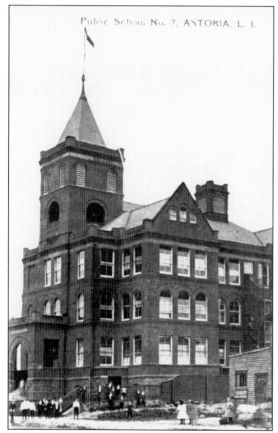

Public School No. 7, ASTORIA, L. I.

Public School 7 was on the east side of 21st Street (Van Alst Avenue) almost opposite 26th Road in Astoria. This three-and-a-half-story brick building was built in 1901. In 1908, a large addition was added on the south side almost doubling capacity. It was destroyed by fire some decades ago.

Public School 8, on Steinway Street, was also known as the old Fifth Ward School. It was built in 1877, partially funded by William Steinway. Expanded considerably in 1891, it was sold to the Long Island City public school system a year later. The school was on the east side of Steinway Street between Ditmars and Potter (23rd) Avenues. After 1908, it was an annex to Public School 84.

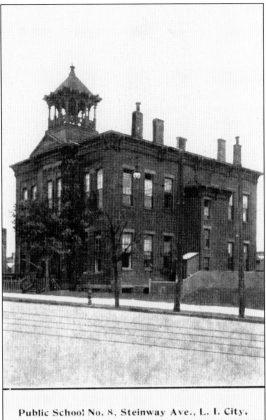

Public School No. 8, Steinway Ave., L. I. City.

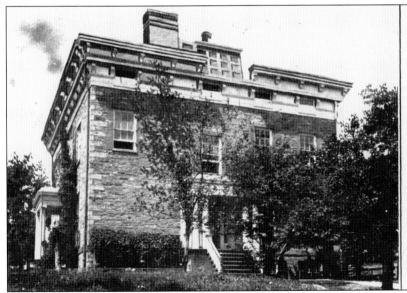

Public School, No. 9, (Formerly High School) Fulton Avenue, L. I. City.

Public School 9 was the former fieldstone mansion of "the Father of Astoria" Stephen Halsey. It was built about 1840. Located on the east side of Second Street north of old Fulton Street (Astoria Boulevard), it became the first Long Island City High School in 1893 and later Public School 9. It was demolished in 1942. The Astoria Houses were built at this location.

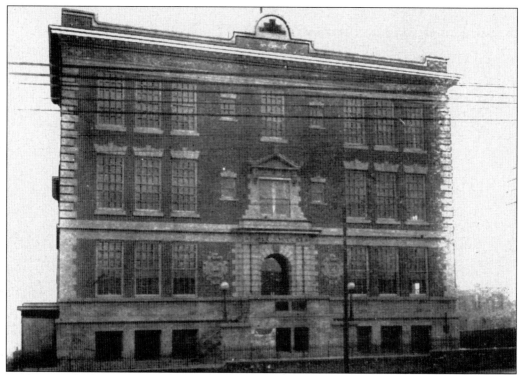

Public School 83, in Ravenswood, was opened in 1906. This four-story brick school was at Vernon Boulevard between Pierce and Graham Avenues (35th and 34th Avenues) and was across the street from Rainey Park. Phoenix House and a number of businesses now occupy the location.

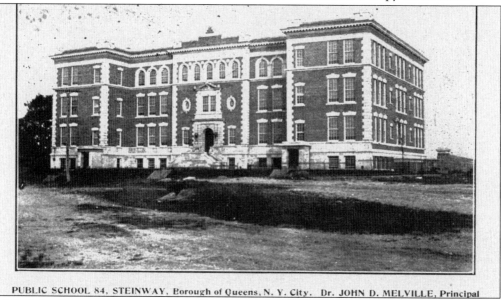

PUBLIC SCHOOL 84, STEINWAY, Borough of Queens, N. Y. City. Dr. JOHN D. MELVILLE, Principal

Public School 84, in the Steinway community, still stands on the east side of Albert (41st) Street, between Ditmars and Potter (23rd) Avenues. This four-story brick school was built in 1904–1906 on property once owned by the Steinway and Sons piano company. John D. Melville was the school principal from 1906 until 1918.

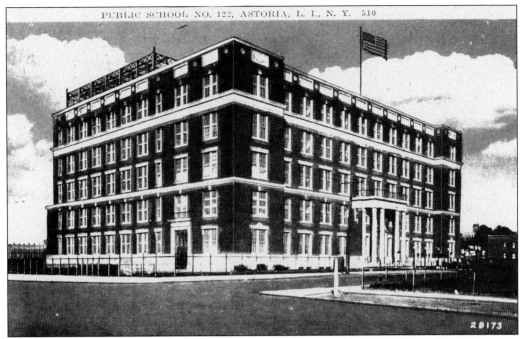

The housing explosion of the 1920s created a huge influx of children of school age. The old school buildings all doubled and tripled in size by later additions. During that decade, a number of large new elementary schools were built, including Public School 122, a five-story brick building on the north side of Ditmars Avenue between 21st and 23rd Streets.

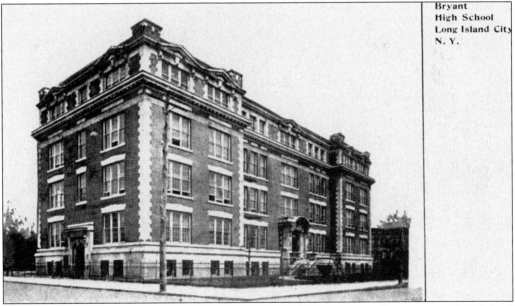

Bryant
High School
Long Island City
N. Y.

Located in the Dutch Kills section of Long Island City, William Cullen Bryant High School was built between 1902 and 1904. The main entrance is on Wilbur (41st) Avenue. When Bryant High School moved to 31st Avenue around 1930, the building received a new name as the Long Island City High School and in 1995, Newcomers High School.

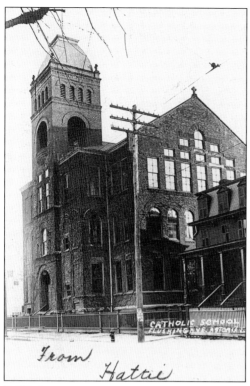

"From Hattie," this postcard was sent to Vangrie Bower of Tivoli, New York, in 1906. Construction of the school building for Our Lady of Mount Carmel at Astoria Boulevard and Crescent Street began in 1891. School opened in September that year with 300 children in four classrooms. Before the convent was built, the staff, six sisters of St. Joseph, traveled daily from St. John's Hospital in Hunters Point.

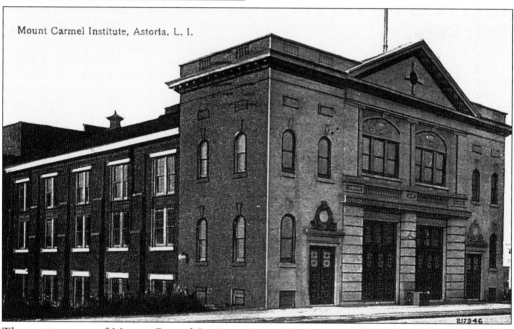

The cornerstone of Mount Carmel Institute (now Mount Carmel Parish Center) was laid in October 1909. Located at 23-20 Newtown Avenue, it has served as the parish hall serving a number of functions including an adjunct to the school, meeting rooms for parish organizations, and as a recreational and gymnasium venue for youth. It is currently home to the parish Catholic Youth Organizations.

St. Mary's School was at one time the largest parochial school in Long Island City. The school got its start back in the 1870s when Roman Catholics (primarily Irish) objected to a mandatory reading from a Protestant bible at the beginning of each school day. The school, opened in 1893, closed a few decades ago.

512. Publ. by Photo. & Art Publ. Co., N. Y.
ST. MARY'S SCHOOL AND CHURCH, L. I. CITY.

ST. MARY'S LYCEUM, Fifth Street, Long Island City

St. Mary's Lyceum has a colorful past. Originally the First District Municipal Court as well as a meeting hall for a number of organizations, in 1955 it became the convent for the Sisters of the Religious of the Sacred Heart of Mary. It has been used by the police athletic league and as a senior center. Its future is uncertain. The building stands on 49th Avenue (the old Fifth Street).

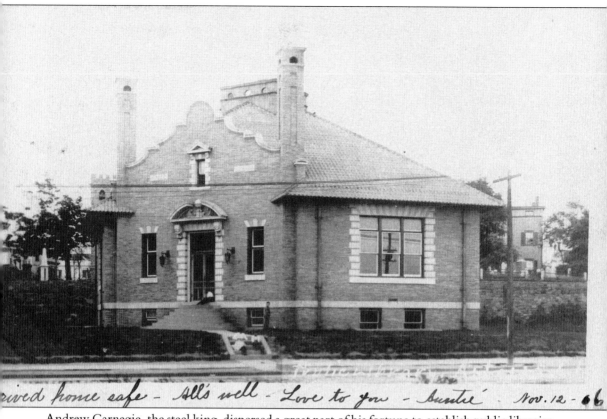

rived home safe — All's well — Love to you — Auntie . Nov. 12 - 66

Andrew Carnegie, the steel king, dispersed a great part of his fortune to establish public libraries. In 1902, the city offered a site at the northeast corner of Astoria Boulevard and 14th Street and submitted plans for a library building. The Carnegie Foundation approved and, in 1904, erected this building at a cost of $26,200. An expansion changed its appearance, but the library is still at the same address.

Five

CIVIC INSTITUTIONS

In the nearly three decades of Long Island City's existence (1870–1898), it developed a full range of civic institutions largely in keeping with those found in any small city. One need not look further than the local hook and ladder company (complete with sturdy horses), the local school, the local library, the local post office, and the local police precincts to see that those institutions, although home grown and independent, were valued by its citizens.

Some institutions were privately funded. In Old Astoria, Stephen Halsey supervised the laying out of streets and turnpikes, the purchase of ferryboats, a local gasworks, and the creation of churches, often from his own pocket.

A generation later, the Steinway family developed a community with a cultural infrastructure designed to attract a workforce from around the world. It showered the Steinway settlement with schools and a kindergarten, churches, a library, a firehouse, a post office, and a transportation network. It built housing and created a shopping district.

Taking advantage of Astoria Village's countrified setting was River Crest Sanitarium. Adhering to the prevailing view of the time that substance addiction was due to "unwholesome" city living, the facility offered patients a rustic environment to help turn their lives around.

Before the modern era of income tax, Long Island City could only create an urban infrastructure of water mains, sewers, and paved streets by borrowing money or taxing property. Urban neighborhoods that were solidly built up, as Hunters Point or Blissville, needed tax revenues that could only come through land assessments on less developed areas, as Astoria. This wealth transfer was a source of tension throughout much if its history, and the city often verged on bankruptcy—which was precisely what officials hoped the 1898 consolidation into Greater New York City would redress.

The Queens County Court House on Jackson Avenue, whose very appearance signified the gravity of its purpose, was the county seat for today's Queens and Nassau Counties. Long Island City has always played an outsize role in the metropolitan area far in excess of its size. Like Brooklyn or New York, it was, after all, a city.

Dear Mrs.
Pirner,
My cous-
in, Mr.
Baumann
belong to
this Stat-
ion House
"Josie."

74th Precinct Station House, Grand Ave., L. I. City.

Josie writes, "Dear Mrs. Pirner, My cousin Mr. Baumann belong[s] to this Station House." On Grand (30th) Avenue near Crescent Street, the 74th Precinct, later the 114th Precinct, was one of only two precincts in Long Island City. The entire force was comprised of a captain, a sergeant, and 75 patrolmen. To judge from the roster of names, it would appear that the police force was 98 percent Irish.

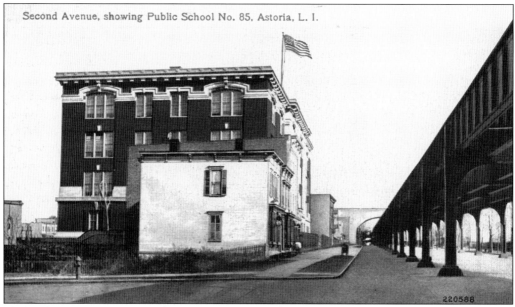

Second Avenue, showing Public School No. 85, Astoria, L. I.

The elevated train and Queensboro Bridge created a housing explosion. Civic institutions and infrastructure, in contrast to today's building boom, kept pace. For example, to handle the huge influx of children, older schools were greatly expanded or new ones were built, as with Public School 85 (1906) on 31st Street between 23rd Road and 24th Avenue. In 1988, the school was renamed to honor Judge Charles J. Vallone.

The Rambler Fire House in Blissville undoubtedly had one of the most difficult areas in the city to patrol. On the banks of Newtown Creek were the highest concentrations of lumber, oil, varnish, and chemical plants in the country. As early as the 1870s, it had to deal with at least one serious fire each year.

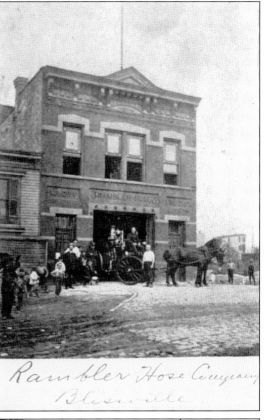

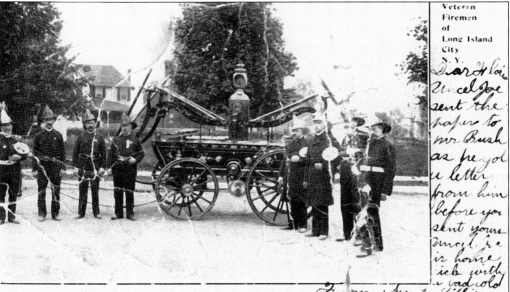

Pieces of Long Island City fire apparatus are still preserved in the New York Fire Museum. There were three retired firemen's associations in Long Island City: the Exempts at 30th Street and 37th Avenue; the Veteran Firemen at Astoria Boulevard and Main Street, and the Volunteer Firemen at 27-01 Jackson Avenue at 43rd Avenue. The last survivor died in 1961.

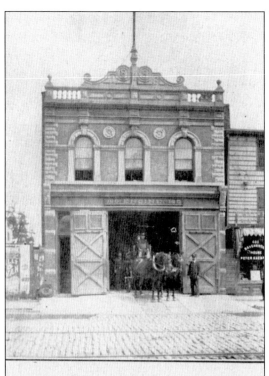

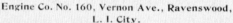
Engine Co. No. 160, Vernon Ave., Ravenswood, L. I. City.

While no longer a firehouse, this building at 36–29 Vernon Boulevard, north of 37th (Webster) Avenue in Ravenswood, and across from the "Big Allis" power plant, has still kept a good portion of the architectural detail. Company No. 160, now known as the No. 260, has a newer house nearby on 37th Avenue.

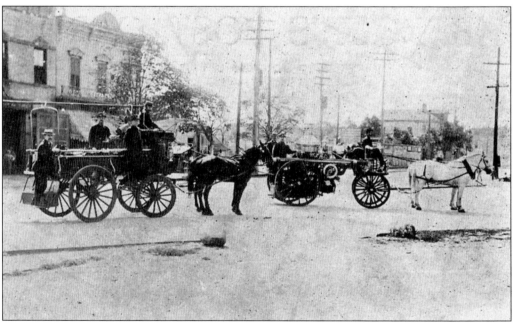

Showing the cutting-edge firefighting apparatus of its time, this engine could pump water from any available water source be it a river, pond, or hydrant. Engine and truck No. 163 was located on Astoria Boulevard (the former Flushing Avenue) east of Steinway Street. It was formerly Engine Company No. 5. The first Astoria fire company was created in 1842.

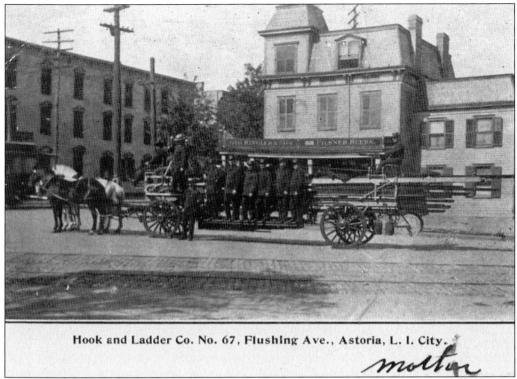

Hook and Ladder Co. No. 67, Flushing Ave., Astoria, L. I. City.

The Hook and Ladder Company No. 67 was originally the Hook and Ladder Company No. 4 on the south side of Astoria Boulevard east of Steinway Street. When Queens became part of Greater New York City in 1898, most of the borough was still served by volunteer companies. The Long Island City fire department, as paid professionals, was absorbed directly into New York City's fire department.

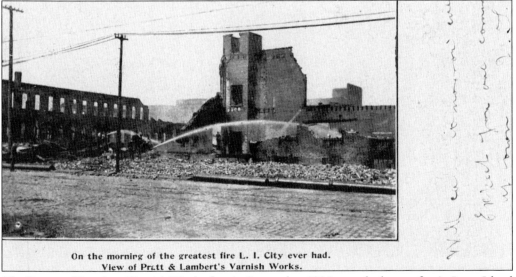

On the morning of the greatest fire L. I. City ever had.
View of Pratt & Lambert's Varnish Works.

The Pratt and Lambert Varnish Works fire, in September 1906, was the largest fire in Long Island City's history. The community was peculiarly vulnerable because of the high concentration of industries producing flammable products like industrial oil, home lamp oil, and varnishes.

85

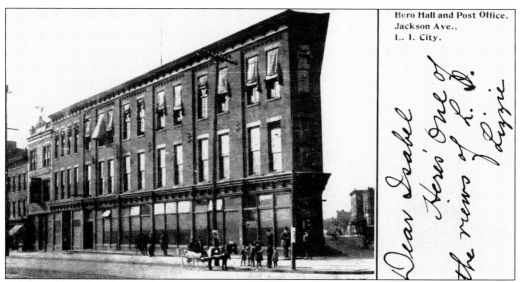

Bero Hall and Post Office,
Jackson Ave.,
L. I. City.

Dear Isabel Here's One of the views of L. I. Lizzie

"Dear Isabel, here's one of the views of L. I. Lizzie." The Hackett Building, at 10-63 Jackson Avenue and 49th Avenue was the first Queens Borough Hall (1898–1916). It was built in the early 1890s as O. Demarest Dry Goods Store, touted at the time as Long Island City's answer to Macy's on Herald Square. In 2007, it was torn down.

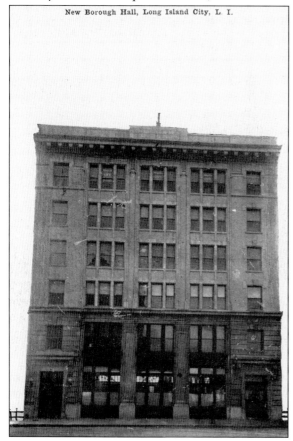

New Borough Hall, Long Island City, L. I.

The Queens Borough Hall, between its departure from the Hackett Building (in 1916) and its move to the current location in Kew Gardens (in 1940), was the Stuart Hirschman Building in Queens Plaza. Along with the chamber of commerce and a number of banking institutions, the plaza fulfilled its promise by becoming the financial and commercial center for Queens.

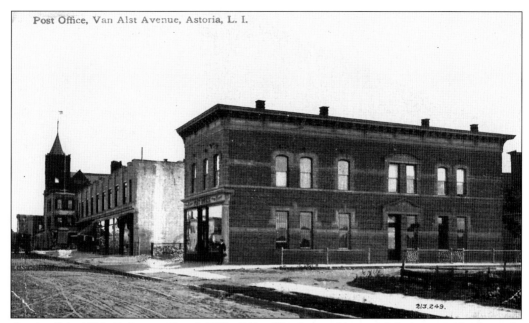

Post Office, Van Alst Avenue, Astoria, L. I.

213.249.

On April 1, 1889, Steinway, Dutch Kills, Blissville, Sunnyside, and Schuetzen Park, formerly independent post offices, were abolished and became stations of the main Long Island City post office. Incidentally, the boundary of the current Long Island City post office corresponds with the historic city limits. The Astoria postal branch is also still on 21st Street (Van Alst Avenue) but in a different building. In the distance is Public School 7.

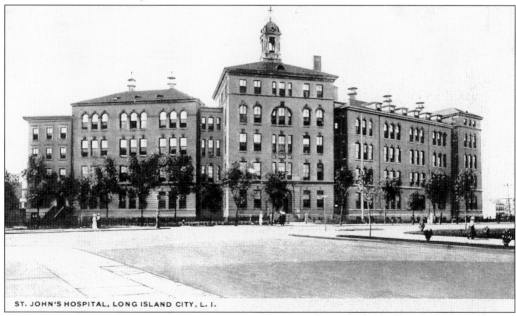

ST. JOHN'S HOSPITAL, LONG ISLAND CITY, L. I.

St. John's Hospital started in 1861, making it the oldest hospital in Queens. In 1897, work began on the new building on Jackson Avenue. The ground floor contained offices and consultation rooms with an operating room and laboratory in the rear. The upper floors were hospital wards. The hospital moved to a new facility in Elmhurst in 1957. This is now the site of the 663-foot, 48-story Citibank building.

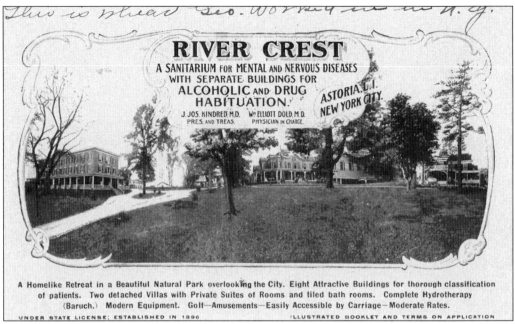

This is where Geo. Worked me in N.Y.

RIVER CREST

A SANITARIUM FOR MENTAL AND NERVOUS DISEASES WITH SEPARATE BUILDINGS FOR ALCOHOLIC AND DRUG HABITUATION.

ASTORIA, L.I.
NEW YORK CITY

J. JOS. KINDRED, M.D.
PRES. AND TREAS.

Wm. ELLIOTT DOLD, M.D.
PHYSICIAN IN CHARGE.

A Homelike Retreat in a Beautiful Natural Park overlooking the City. Eight Attractive Buildings for thorough classification of patients. Two detached Villas with Private Suites of Rooms and tiled bath rooms. Complete Hydrotherapy (Baruch.) Modern Equipment. Golf—Amusements—Easily Accessible by Carriage—Moderate Rates.

UNDER STATE LICENSE: ESTABLISHED IN 1896 ILLUSTRATED BOOKLET AND TERMS ON APPLICATION

Established in 1896 on the 30-acre Wolcott estate, River Crest Sanitarium cared for patients until the 1920s. The private sanitarium catered to nervous diseases, alcoholism, and drug addiction. Its founder, Dr. John Kindred, went into politics and became a congressman from Astoria. Kindred Street was a former name of 26th Street north of Hoyt Avenue.

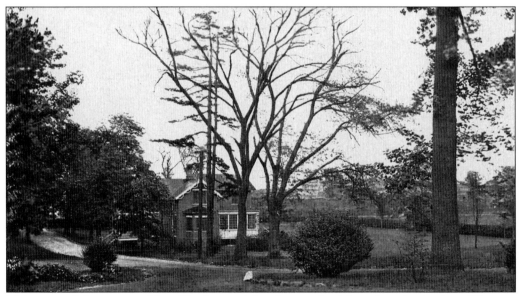

This postcard shows one of the villas for special patients at the River Crest Sanitarium. The area was one of the last major plots of land to be developed. First Mater Christi High School, now St. John's Prep High School, occupies this block.

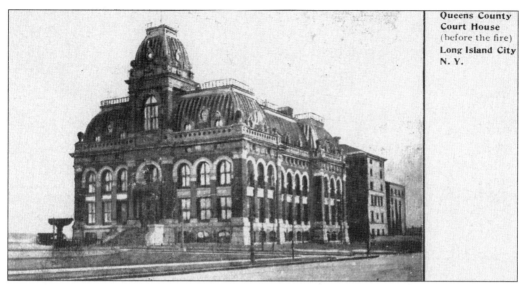

Dedicated in April 1877, the Queens County Court House was designed by architect George Hathorne. It served a number of civic functions, including being the county seat for Queens County. The bitter controversy over its location (at Hunters Point where the Long Island rail network converged) eventually led the eastern towns of Queens to secede, forming Nassau County. The courthouse was destroyed in a 1904 fire.

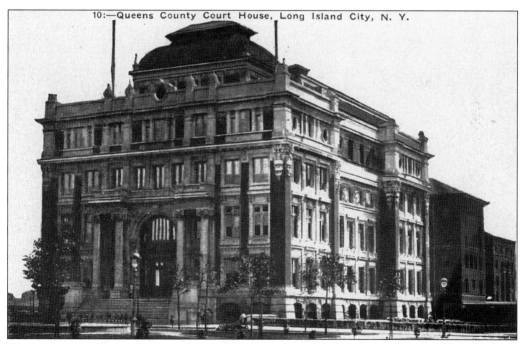

10:—Queens County Court House, Long Island City, N. Y.

The present courthouse, built on the foundation of the old, was designed by Peter M. Coco in 1904. It witnessed the Ruth Snyder trial and Willie Sutton's imprisonment and survived a bomb set off by the Weathermen, a radical group from the 1970s. It is designated as an official New York City landmark and is registered with the National Register of Historic Places.

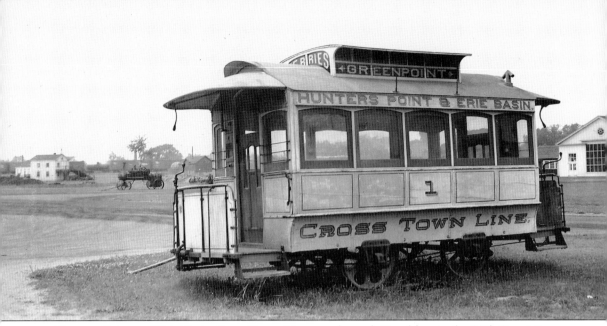

Hunters Point and Erie Basin Cross Town Line ran through Brooklyn to the 34th Street Ferry in Hunters Point. The routes of the first trolley network in Long Island City (1870s) were a large factor in dictating the community's growth along Vernon and Astoria Boulevards, Broadway, and Steinway Street. Service to Calvary and nearby cemeteries gave another important boost to transit development.

Six

COMMERCE AND TRANSPORTATION

Inasmuch as merchants drove the economy in early Long Island City, larger enterprises played a role also. Industrial development flourished in Long Island City in the 19th and early 20th centuries, thanks to local banks quick to invest in the area, open space enabling physical plants to expand, and, of course, the East River and Newtown Creek. The Long Island Rail Road played a vital role within the transportation network, moving along the nation's economy. Successful enterprises that emerged, such as the Steinway piano company, grew to become familiar household names. Long Island City was home to a number of foodstuff manufacturers, in particular, including Ronzoni pasta (another preeminent company that also began as a family business), Chiclets chewing gum, Sunshine Biscuits, and none other than Pepsi-Cola topping the list.

While these companies and others like them would be hard-pressed to deny their local roots, some felt compelled to leave, more for self-defined reasons than Long Island City's allure. In the late 1990s, the Swingline Stapler Company signaled the end of its seven-decade run in Long Island City by unhappily announcing that it was moving its operations to China and Mexico. A sign of the times, perhaps, but Swingline's departure constitutes another open wound that, to residents, will not ever heal properly.

From the standpoint of government, Queens County's decision to stake its future in consolidation over a century ago was with the hope that economic development would follow soon thereafter. Nothing embodied this more elegantly than the construction of the Queensboro Bridge, completed in 1909, a marvelous example of municipal infrastructure to this day. Its appearance, however, eclipsed the erstwhile reliable and quaint ferry services to Manhattan (as 1936 came to a close, the *Rockaway* marked their final end with its last run between Astoria and 92nd Street). Soon on the scene were sturdy trolley cars filled with passengers making runs across the bridge, within Queens Plaza, and beyond. Higher-volume train service to and from Manhattan only came in earnest later.

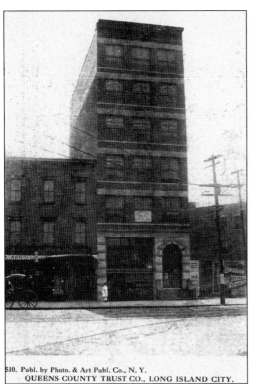

The Queens County Trust Company, based in Jamaica, through a series of mergers, is part of the JPMorgan Chase network. The Long Island City Savings Bank was organized in 1876, and the Queens County Bank located at the ferry in 1888. The old bank building, erected in 1890 of massive stone and brick, is still standing near the foot of Borden Avenue.

510. Publ. by Photo. & Art Publ. Co., N. Y.
QUEENS COUNTY TRUST CO., LONG ISLAND CITY.

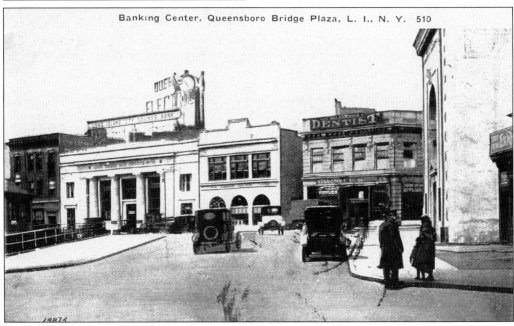

Banking Center, Queensboro Bridge Plaza, L. I., N. Y. 510

The Queens Plaza, with the borough hall, chamber of commerce, and temples of finance, was the financial and political center of Queens. First Mortgage Guaranty, Long Island City Savings Bank (1920), Title Guarantee and Trust Company (1922), Bank of Manhattan (1927), National City Bank (1928), and Chatham Phoenix Bank and Trust Company (1928) had branches at the plaza.

The Bank of Manhattan, called the "clock tower building," was put up in two sections with the tower a much later addition. The building, completed in 1925, was the set piece for the Long Island City skyline. Bridge Plaza was expected to be the new Times Square of Queens. The 14-story building is graced with a recently restored four-faced clock.

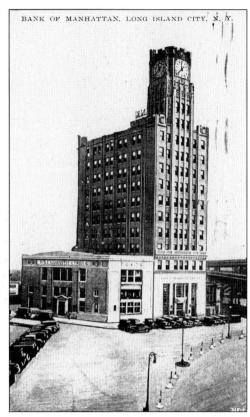

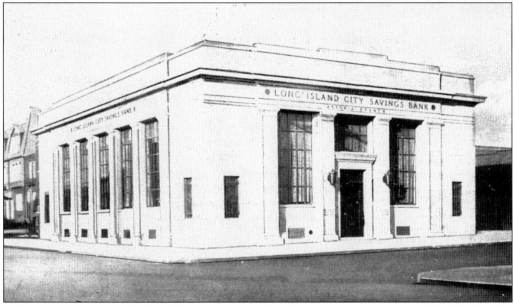

The Long Island (City) Savings Bank, headquartered in a stunning art deco lobby on Queens Plaza, opened a number of attractive branch offices. This building (with a lovely little pocket park) was built in 1924 on 30th Avenue. A developer with an interesting flair for style expanded the building over the park and added several stories.

The corner of Fulton Avenue and the Boulevard, a block long gone, would be near the intersection of Astoria Boulevard and Main Avenue. Traffic to the Manhattan ferry along roads from Flushing and from Brooklyn created a small business district in Old Astoria. This is now part of Hallets Cove Playground.

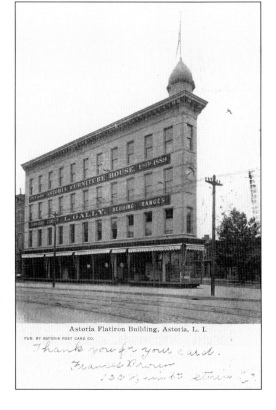

For nearly 100 years, the "Astoria Flatiron" building was home to a parade of furniture stores, from Gally Furniture to Ethan Allen. This is a fine example of a business postcard from the medium's heyday. The building still stands proudly at Astoria Square. See page 38 for a different view of the flatiron building.

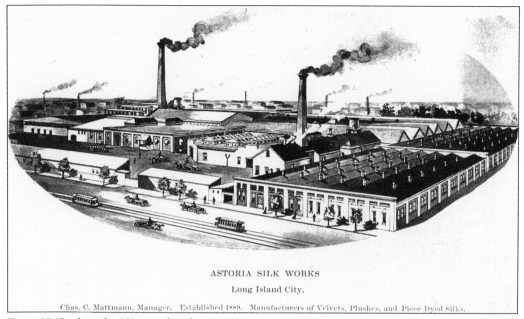

ASTORIA SILK WORKS
Long Island City.

Chas. C. Mattmann, Manager. Established 1889. Manufacturers of Velvets, Plushes, and Piece Dyed Silks.

From 1845 when the Higgens brothers set up a carpet-weaving business in Sunswick Meadows to the departure of Scalamandré Silk in 2004, weaving was an important industry in the community. About 100 years ago, the Steinways invested in the Astoria Silk Works, and the buildings of the long-defunct company are still on 23rd Avenue near Steinway Street.

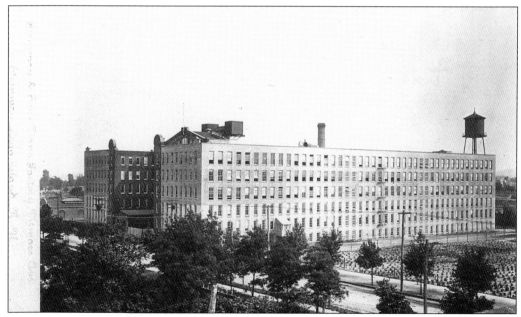

The Steinway and Sons piano factory, at the end of Steinway Street since 1870, still makes an instrument that is played by 99 percent of artists of the stage and studio. The Ditmars plant, on this postcard, was sold in the 1950s and converted to apartments of unusual design.

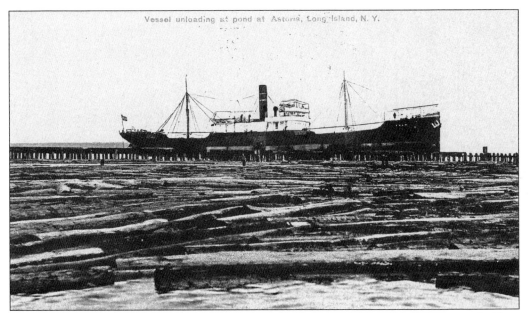

At Luyster (Steinway) Creek near Berrian's Island, a tramp steamer unloads logs into holding pens. Used mostly as veneer, rare and exotic wood from around the world was shipped to Astoria Village, home to firms as Tisdale Lumber and Astoria Mahogany. The Steinway and Sons piano company used to float enormous log rafts from New England through Long Island Sound to its factory on the creek.

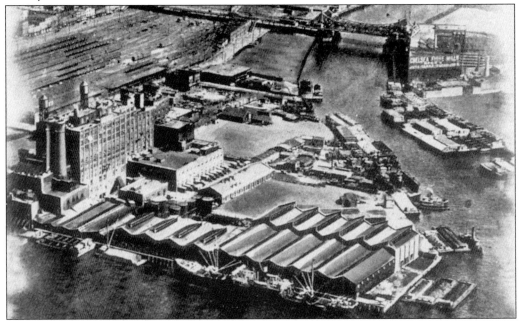

The National Sugar Company, at the mouth of Newtown Creek, was the largest sugar refinery in the country. It sold sugar under the name Jack Frost. The government shut down the plant during World War II as it felt that sugar refining would be more efficient closer to the fields. In the background is the Vernon Avenue Bridge over the creek and rail yard. This location is earmarked for housing.

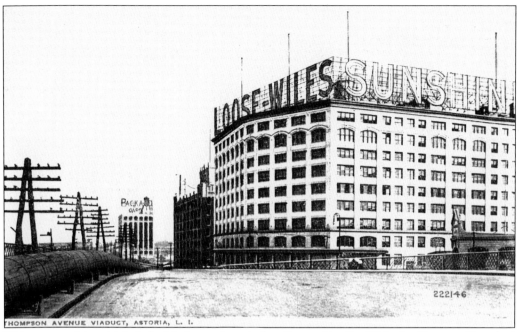

This postcard is mislabeled: this is not Astoria but Sunnyside. In 1905, the Degnon Terminal and Realty Company incorporated with capital of $1 million. Three inducements for business to locate at the terminal were space, rail facilities, and cheap shipping by water. The first big client was the Loose-Wiles Biscuit Company. Its massive 10-story concrete building at Skillman and Thomson Avenues had 800,000 square feet.

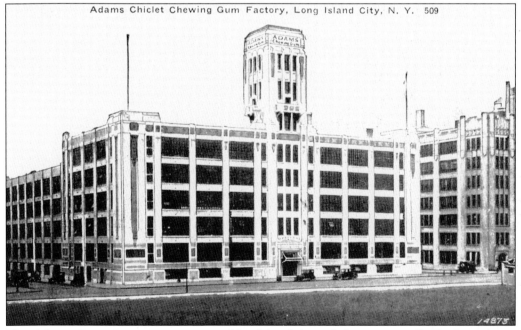

The Adams Gum Company was started by "the father of chewing gum" Charles Adams. It produced Chiclets, Dentyne, Halls, and Trident. The building is still standing along the Sunnyside Yards.

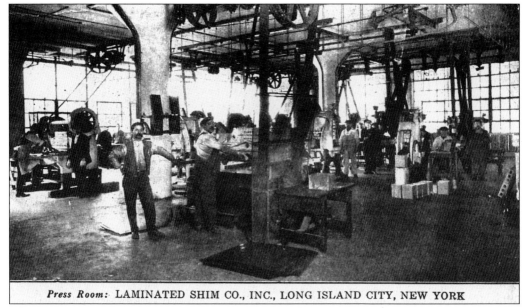

Press Room: LAMINATED SHIM CO., INC., LONG ISLAND CITY, NEW YORK

Started in 1924, the Laminated Shim Company is still going strong. It moved to California some years ago and today produces components for the aerospace industry.

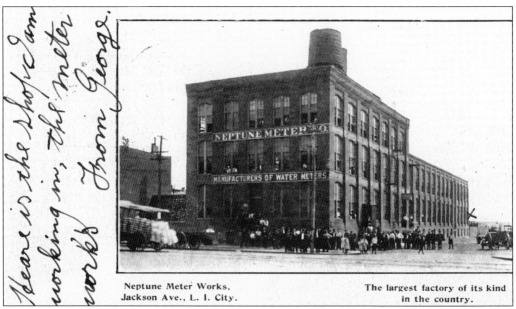

Neptune Meter Works,
Jackson Ave., L. I. City.

The largest factory of its kind
in the country.

"Heare [*sic*] is the shop I am working in, the meter works. From George." The Neptune Meter Company produced residential water meters in the biggest factory of its kind in the country. Neptune expanded its product line through expansion and acquisitions. It moved from its Jackson Avenue plant in Long Island City in 1972 and is now a subsidiary of the world's largest meter manufacturer.

Karpen Brothers Furniture started in Chicago and opened a number of factories throughout the country, including this location on Northern Boulevard. The company was sold in 1952. The name was used for a furniture line through the 1970s.

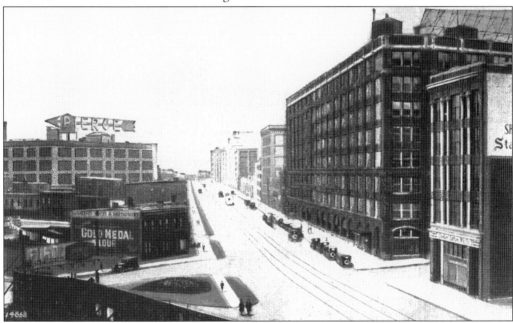

Automobile companies such as Rolls-Royce, Mercedes, Packard, and Pierce Arrow assembled cars in Long Island City. Henry Ford erected this building on Jackson Avenue (now Northern Boulevard) in 1915. It was later the Roto Broil factory owned by Leon Klinghoffer, the unfortunate victim of terrorists aboard the *Achille Lauro* in 1985. This view was taken from near the elevated train platform at 39th Avenue.

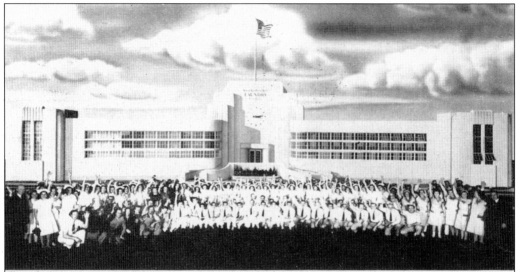

The plant workers, office workers, and management of the Knickerbocker Laundry wave a cheery greeting to their thousands of friends. — In the background is the million dollar Knickerbocker Laundry plant in Long Island City.

KNICKERBOCKER LAUNDRY　　-:-　　LONG ISLAND CITY　　-:-　　RAvenswood 8-7700

This card reads, "The plant workers, office workers, and management of the Knickerbocker Laundry wave a cheery greeting . . . In the background is the million dollar Knickerbocker Laundry plant in Long Island City." The plant went through a number of owners before being bought by a church in the 1990s. Despite promises that the facade would remain, it was completely altered. It is on Barnett Avenue in Sunnyside.

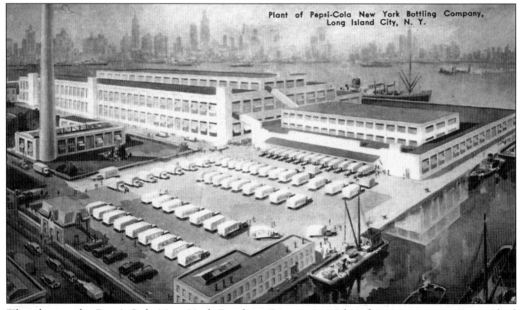

The plant at the Pepsi-Cola New York Bottling Company, and its famous neon sign, once had a commanding presence on the East River at Fifth Street in Long Island City. Old-timers still fondly recall Saturday night dances sponsored by the company. The factory was recently torn down for a high-rise condominium complex, but the iconic neon Pepsi-Cola sign, erected in 1936, was saved.

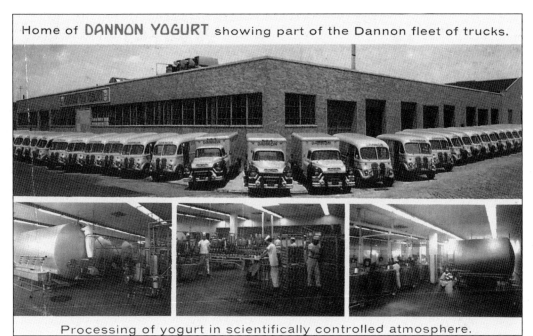

Home of **DANNON YOGURT** showing part of the Dannon fleet of trucks.

Processing of yogurt in scientifically controlled atmosphere.

Dannon was founded by Isaac Caraso in 1919 and is named for his son "little Danny." Caraso was an olive oil merchant of Jewish Greek origin who introduced yogurt, a dietary staple in the Balkans, to the world. Selling yogurt originally as a medicine in Spain, the company took off after Caraso immigrated to the United States in 1942 and introduced fruit to the product in 1947.

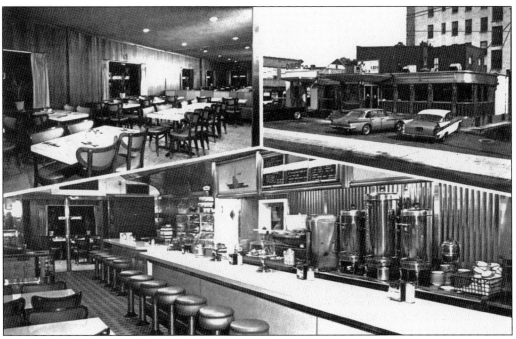

This is a modern card from the 1960s. The building is still at the southeast corner of 46th Street and Broadway, but the diner is long gone. Postcards still remain a cheap and effective means for small businesses to advertise.

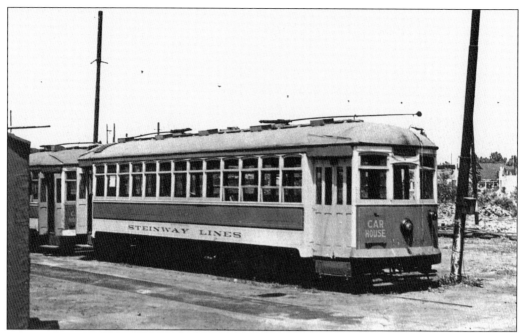

Everyone associates the Steinway name with music, but not as well known are its impressive accomplishments in areas far removed from its piano company. In transportation, at one time it controlled the trolley system in western Queens, chaired the first New York City subway commission, and drew up the first plans to bring rail lines from the continental United States to Queens.

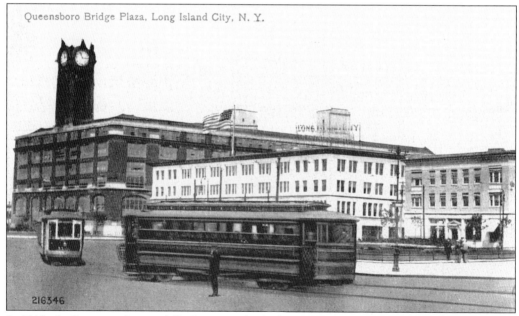

Queensboro Bridge Plaza, Long Island City, N. Y.

In 1910, the Brewster Automobile Company built the majestic Brewster Building. It had marble floors and an ornamented foyer. Recently expanded and given a face-lift, it still stands on the plaza's north side between 27th and 28th Streets. Unfortunately, the clock tower was removed a few decades ago. The building has 50,000 square feet of floor space on each floor.

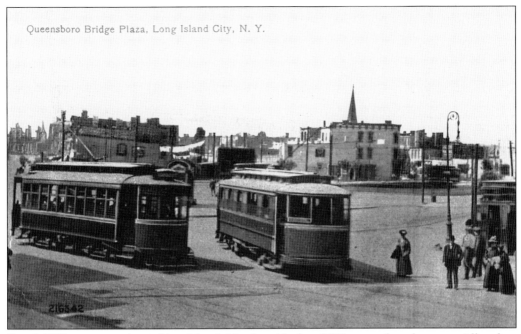

Queensboro Bridge Plaza, Long Island City, N. Y.

Dutch Kills, once a quiet residential neighborhood before 1909, started to change rapidly when it suddenly found itself the site of Bridge Plaza. Jane Street (Bridge Plaza North and South), a residential street, now was transformed into the broad Queens Plaza from 24th Street to Jackson Avenue. The doomed community is in the background on this postcard. A trolley waiting room is on the right.

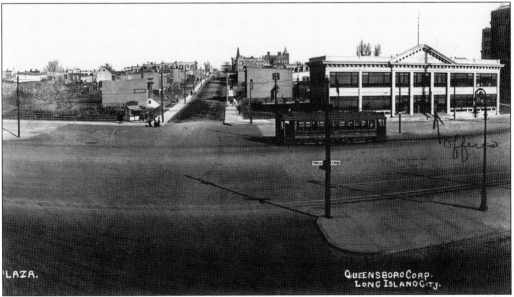

In one of the first buildings on Queens Plaza, the Queensboro Corporation promoted its new elegant residential enclave in Jackson Heights. Although it was marred in the early 1960s with a walkway to Queensboro Plaza, the building still houses numerous businesses. In the center are Crescent Street and Queens Plaza North. A trolley passes through a recently opened and empty plaza.

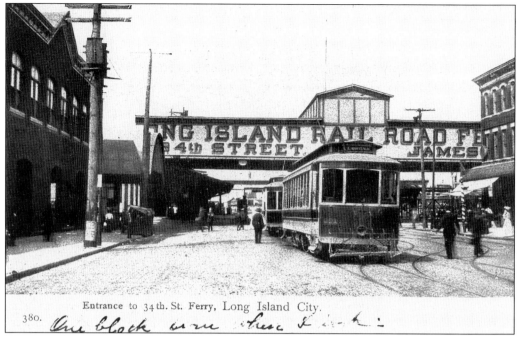

Entrance to 34th. St. Ferry, Long Island City.

380. *One block from where I work:*

"One block from where I work," reads this postcard. Upon the arrival of the Long Island Rail Road in 1861, the Hunter's Point–34th Street ferry terminal at the foot of Borden Avenue became the busiest hub on all Long Island. Horsecars and, later, electric trolleys ran along Borden Avenue to Calvary Cemetery in Blissville, along Vernon Avenue to Astoria, and along Steinway Avenue to North Beach Amusement Park.

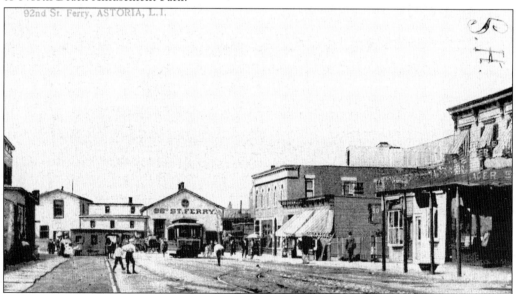

92nd St. Ferry, ASTORIA, L. I.

A ferry ran as early as the 1760s, and a small hamlet grew at Hallets Cove supporting a few merchants. This was the only direct route to Manhattan from Queens. By 1861, with the opening of Jackson Avenue (Northern Boulevard) and the Long Island Rail Road terminal in Hunters Point, most through traffic from Long Island bypassed Astoria. In the 1890s, ferry service shifted from 86th Street to 92nd Street.

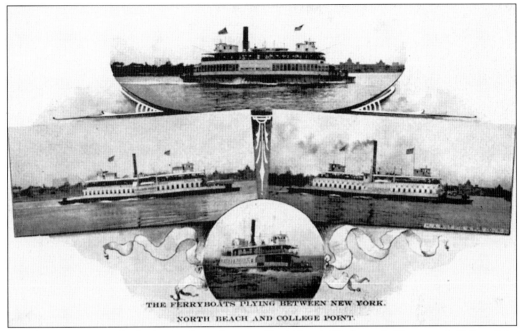

THE FERRYBOATS PLYING BETWEEN NEW YORK.
NORTH BEACH AND COLLEGE POINT.

The ferries are named, clockwise from the top, *North Beach*, *Hackensack*, *Bronx*, and *College Point* and plied their trade between Witzel's in College Point, Clason's Point in the Bronx, and North Beach. Excursion ferries carried thousands of people from crowded city neighborhoods to the fresh, open-air resort destinations along the East River and Long Island Sound.

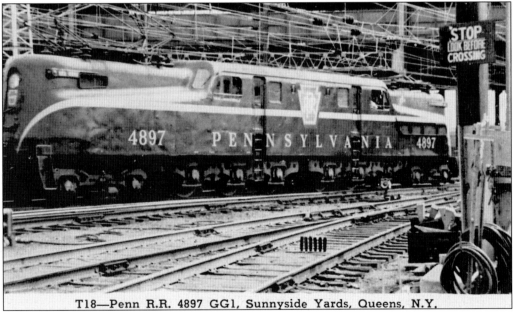

T18—Penn R.R. 4897 GG1, Sunnyside Yards, Queens, N.Y.

GG1 was an electric locomotive developed by the Pennsylvania Railroad. Sunnyside Yards was the eastern limit of the railroad's range until the Penn Central merger. Most of the GG1s were locally used for fast passenger or mail and express package trains. They served longer than any other American locomotive design, from 1934 to well into the 1980s. This unit, No. 4897, was scrapped.

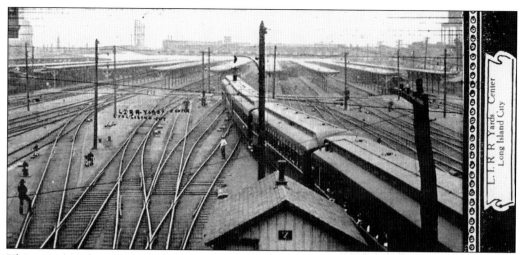

The main line for the Long Island Rail Road terminated at Hunters Point in Long Island City, the destination for most of the traffic on the island. From there passengers would take the ferry to 34th Street in Manhattan. This is a rare view of the train platforms.

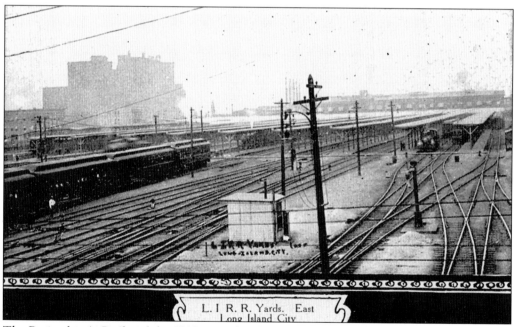

The Pennsylvania Railroad, by 1910, completed its ambitious plan to build tunnels from New Jersey to Manhattan, then over to Long Island City, and finally to lay out a vast railroad yard in the Sunnyside area. As there was no space to turn or store trains in midtown Manhattan, the railroad decided to construct a large storage yard and commissary facility on cheap land in Queens.

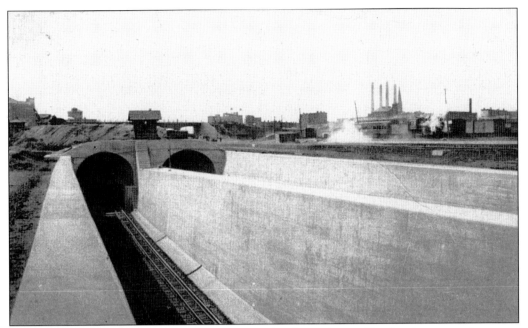

The East River tubes enter Long Island City under the station on Borden Avenue and come to the surface at 21st Street and Hunters Point Avenue. The first test train ran through on April 13, 1910, and on September 8 that year, regular train operation began. This postcard shows the tubes right after their opening.

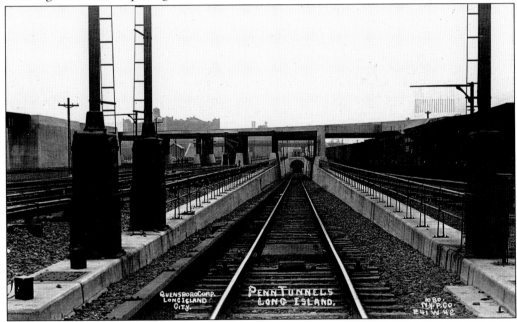

The Pennsylvania Railroad built just two rail tunnels to pass under the Hudson River to Pennsylvania Station at Seventh Avenue and 33rd Street but four tunnels to continue from there to Long Island City. Two were for its own use and two for the Long Island Rail Road, a subsidiary of the Pennsylvania Railroad purchased for the sake of its real estate holdings and rail connections.

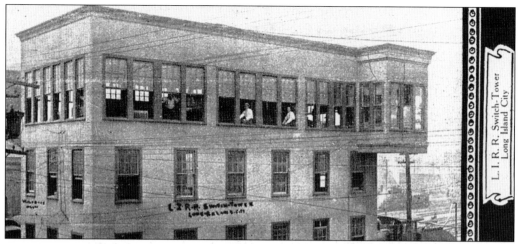

Towers are placed where there are a large number of track switches. These groupings of track switches allow trains to change tracks. At the massive Sunnyside Yards, operators in the tower ran the controls that moved the switches, controlled the signals, and routed the trains under routing instructions from the yardmaster. As each train went by the tower, it was visually inspected as well as logged into the system.

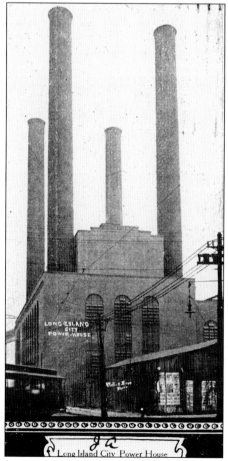

Long Island City Power House

The Pennsylvania Railroad's power plant, designed by McKim Mead and White, supplied power to the tunnels from Long Island to Pennsylvania Station in Manhattan, and beyond to New Jersey. It rests on an eight–foot concrete pad with 9,113 piles under it. Four enormous smokestacks, each 23 feet in diameter and 275 feet high, were removed in 2005. The building found new life as luxury residential housing.

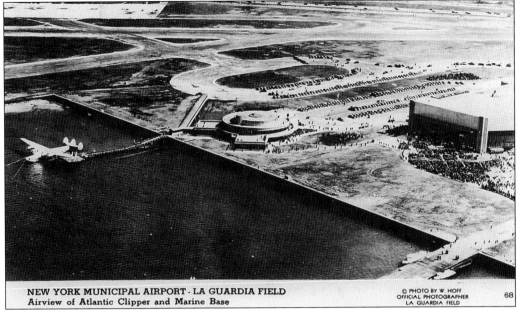

NEW YORK MUNICIPAL AIRPORT - LA GUARDIA FIELD
Airview of Atlantic Clipper and Marine Base

© PHOTO BY W. HOFF
OFFICIAL PHOTOGRAPHER
LA GUARDIA FIELD
68

When North Beach Amusement Park closed (see chapter 7), the property became an airfield that later became LaGuardia Airport. It was dedicated on October 15, 1939. The first Yankee Clipper flights to Europe (pictured) briefly ushered in the aviation age in the few months before World War II. Once hailed as "the greatest airport in the world," its small size limits it to mostly domestic commercial traffic.

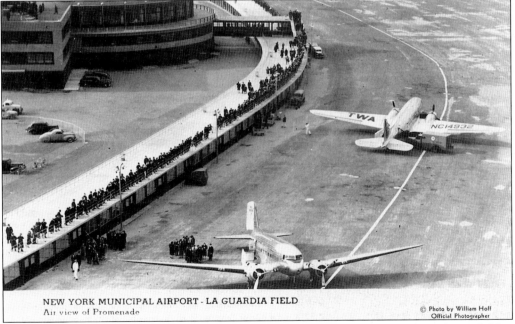

NEW YORK MUNICIPAL AIRPORT - LA GUARDIA FIELD
Air view of Promenade

© Photo by William Hoff
Official Photographer

It is difficult to believe that at one time passengers and friends could stand on the airfield as aircraft taxied nearby. In the 1950s, local kids could ride their bicycles right up to planes and were treated to cookies by stewardesses. TWA, with a history of innovations in aircraft and service, was the first carrier to start nonstop service between New York and Los Angeles in 1953.

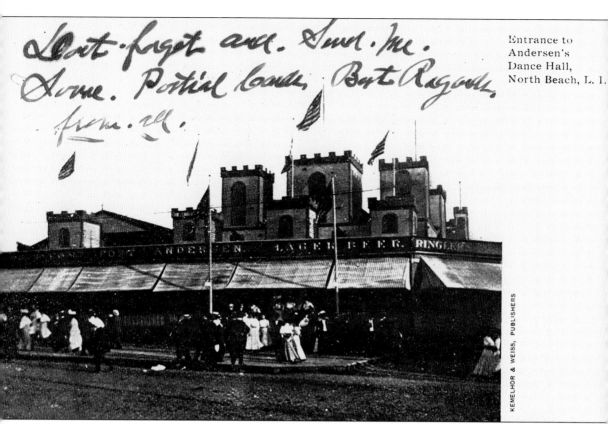

Lest forget and send me some. Partial [illegible], Best Regards from all.

Entrance to
Andersen's
Dance Hall,
North Beach, L. I.

KEMELHOR & WEISS, PUBLISHERS

North Beach was on the East River where LaGuardia Airport is today. The park was actually a series of concessions rented out yearly by George Ehret (who kept the resort well supplied with beer) and the Steinways (who made the resort readily accessible by trolley). Dancing pavilions, such as Andersen's Dance Hall, were very popular and often had contests for king and queen of the hall.

Seven

RECREATION

The people in Long Island City were always ready for fun. Happily, a variety of amusements were available. Folks whiled away hot summer days on the East River or, just as well, at North Beach off Bowery Bay. Although the beach was always popular, men more than women took advantage of the water to cool off; women, perhaps sensitive to social norms, had to be content catching the sea breeze off the shoreline. North Beach offered a pavilion for those who preferred a dignified stroll to take in the scenery and a dance hall for the more vivacious. Children were no doubt spellbound by its theme park, complete with Ferris wheel, chute slide, and—best of all—a grand carousel. All these pleasantries, however, sadly made way for the arrival of LaGuardia Airport later on.

Movie houses offered the most democratic form of leisure available. Presenting this in fine form was the Loew's Triboro Theater, a grand movie house that prominently stood on Steinway Street until 1974, when a bid to preserve it from the wrecking ball proved unsuccessful.

Long Island City could boast forms of entertainment from many ethnic communities; this could be claimed as a long-standing neighborhood tradition. Earlier generations saw the Irish gathering in local pubs in Sunnyside and the Germans regaling in Schuetzen Park like that in the home country. In similar fashion, Czechs went to Bohemian Hall and Park, today the last remaining beer garden in New York City and still enjoying a lively crowd. In mid-century, Italian fraternal orders and Greek *syllogoi* (pronounced SIL-oh-ghee) made their distinctive appearance. Given the powerful sense of nostalgia the Greeks have for their roots, syllogoi are associations dedicated to a particular region, or even village, in Greece. Recently, Hispanic, Croatian, Middle Eastern, and Asian clubs have emerged and provide a semblance of home to their respective peoples. Yet irrespective of where in the world these ethnic organizations show their affinity for, their purpose is universal: to bond people through good food, song, and laughter.

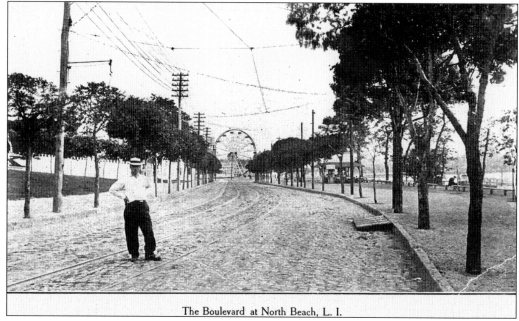

The Boulevard at North Beach, L. I.

An old advertisement for North Beach reads, "Just the Place Where One May Have an Enjoyable Day's Outing!" North Beach had it all: bathing by electric lights (one of the first places in Queens with electricity in the 1890s), vaudeville, dancing, weekly fireworks displays, and concerts every day. The Ferris wheel in the background was part of the midway at North Beach.

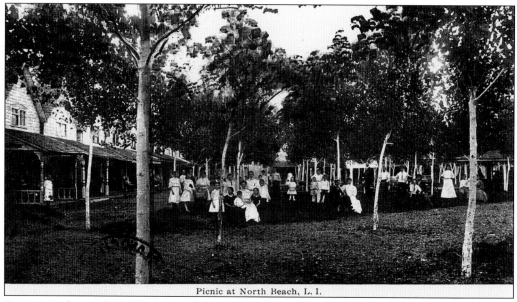

Picnic at North Beach, L. I.

For men, who worked six days a week, North Beach provided good beer and conversation; for women, who worked long hours at home, it offered relaxation and other women's company; for children, it was a place to run around and have fun under their parents' watchful eyes. At a time of low salaries and crowded tenements, packing a picnic lunch was an affordable leisure activity for working-class families.

112

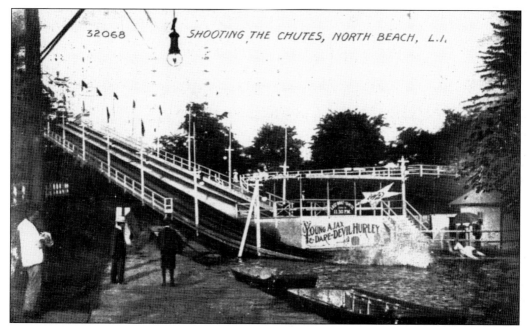

Gala Park was a separate amusement area within North Beach. In the lower right corner is a star with the initials GP for Gala Park. One of the main attractions was Shoot the Chutes. After plunging over 75 feet into a man-made lake, the boat was pulled over to the side and people would re-create the excitement for a souvenir photograph.

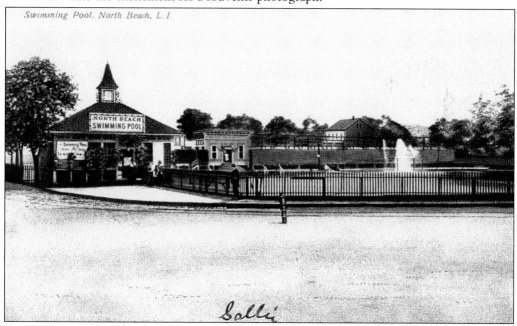

Although North Beach was on Bowery Bay on the Queens north shore, very few visitors swam in the bay. Over 104 bathing houses (sometimes called bathing pavilions) were built at North Beach at a cost of over $6,000. The average price for bathing tickets was 25 tickets for $4 while single tickets were 25¢ for adults, 15¢ for children. The most popular was Deutschmann's Silver Spring Bathing Pavilion.

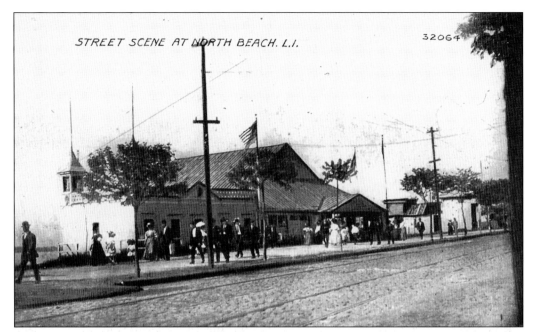

In announcing the opening of North Beach in 1886, officers of the Bowery Bay Improvement Company—Henry Cassebeer, president; William Williams, vice president; William Steinway, treasurer; and George Steinway, secretary—announced that the park was to be "second to none, as a place of resort of respectable people seeking recreation."

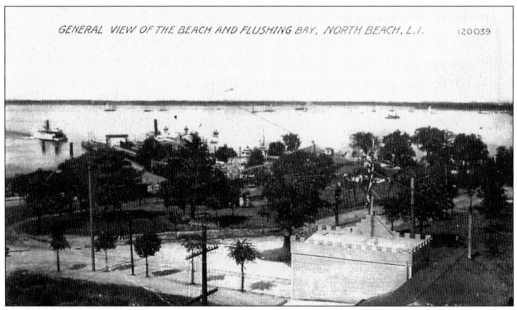

Over 6,000 people came to North Beach on Bowery Bay on opening day in June 1886. In 1891, the name Bowery Bay was changed to North Beach so as not to be confused with the infamous Bowery in lower Manhattan. An advertising brochure read, "North Beach, L. I. The Ideal Family and Pleasure Resort: Shooting the Chutes, Mammoth Carousels, Toboggan Slides, Pony Tracks, Bathing, Ferris Wheel and other up-to-date amusements."

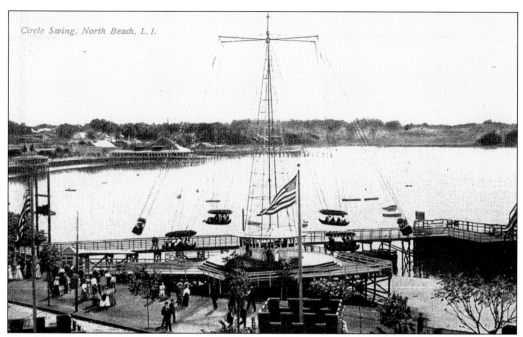

Circle Swing, North Beach, L. I.

The Circle Swing was a series of covered boats that swung around a pole. Swings, such as the Circle Swing, were popular in amusement parks. Coney Island had a similar ride called the Wedding Ring. These attractions allowed adults to shed the boundaries of adulthood and relive a spirit of childhood recklessness.

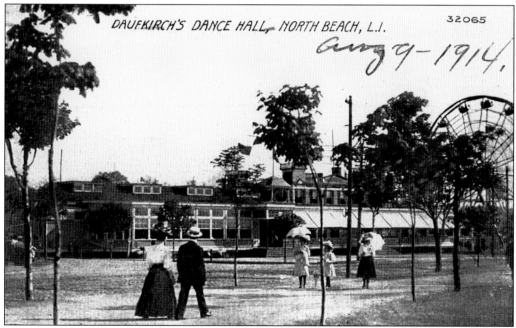

DAUFKIRCH'S DANCE HALL, NORTH BEACH, L.I. 32065

At Henry Daufkirch's Bay View House and Dance Hall, one could enjoy a variety of performances by first-class talent on Sundays. The Club House and Grand Pavilion had choice wines, liquors, cigars, and meals at all hours (served to order). Professor Schweitzer's Orchestra offered dancing every afternoon and evening.

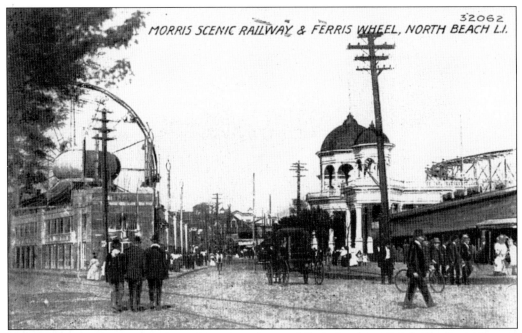

The Ferris wheel, introduced in Chicago at the World's Columbian Exhibition in 1893, was featured at North Beach. An engineering marvel, riding the wheel gave visitors a rare opportunity for an aerial view of North Beach. A ride was two revolutions. Scenic railways, as Morris Scenic Railway, were an early version of the roller coaster.

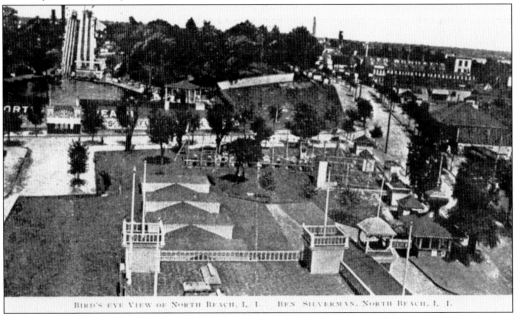

Large double-decked ferryboats from the foot of East 92nd Street in Manhattan brought thousands directly to the North Beach Grand Pier. The ferries traveled hourly on weekdays and every 30 minutes on Sundays for a fare of only 10¢. In 1887, the Steinways opened a branch horsecar line along 19th Avenue, Astoria, from Steinway Avenue to carry the summer crowds to North Beach.

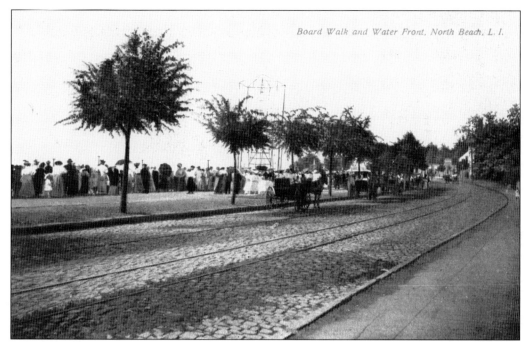

Board Walk and Water Front, North Beach, L. I.

North Beach was one of the first venues catering to a mass market. Although many attractions charged an admission fee, there were many working-class families who could not afford to spend their nickels and dimes. There were many people who came to North Beach merely for the experience of the crowds.

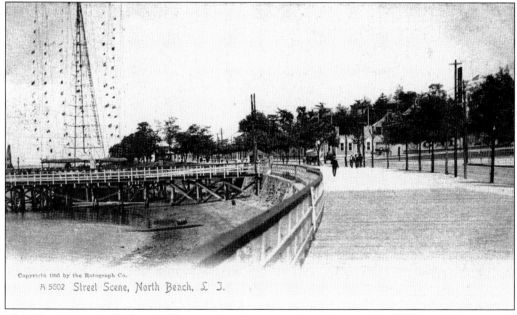

Copyright 1905 by the Rotograph Co.
A 5602 Street Scene, North Beach, L. J.

The Grand Pier, built for the Bowery Bay Improvement Company by William Steinway and George Ehret, helped make North Beach into one of the first amusement resorts in New York. The pier, at the end of the picnic grove, extended 500 feet out into Bowery Bay and was 140 feet wide.

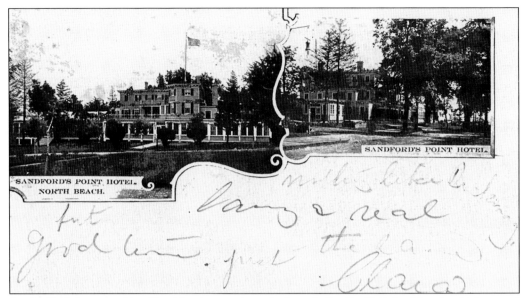

Sanford's Point was a bit of land jutting out into the bay. At Sanford's Point Hotel, which served George Ehret's Extra Beer on draft, singing societies and chowder clubs were a specialty. "Having a real good time" is written on the postcard. Clara sends a souvenir of her day at North Beach to her friend.

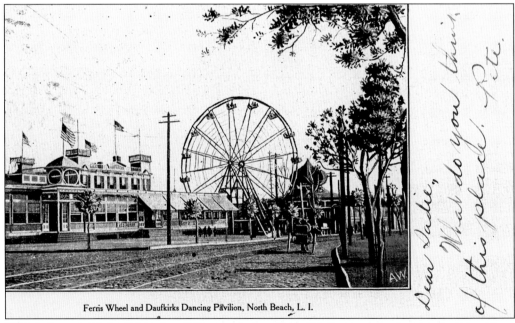

Ferris Wheel and Daufkirks Dancing Pavilion, North Beach, L. I.

"What do you think of this place," Pete writes to Sadie. Unfortunately, almost all of the direct witnesses to North Beach have passed on. Their affection for North Beach only remains for those lucky enough to have heard their stories or memorialized with these few fleeting comments. When Prohibition became law in 1919, North Beach saw the beginning of its decline. Many concessions closed when they could no longer serve beer.

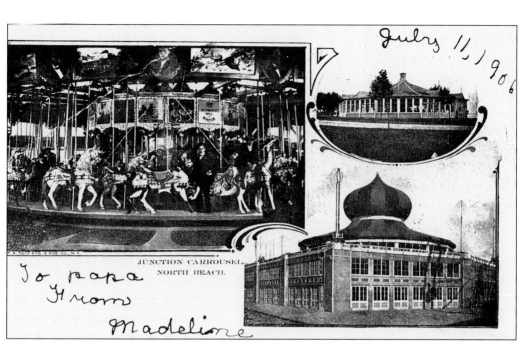

The carousel was a favorite attraction at North Beach. The cost of the ride was 5¢, just as much as the trolley fare to North Beach. The Junction Carrousel, previously called Kremer's Silver Spring Carrousel, had hand-carved horses who magically took riders around and around while they tried to grab the gold ring.

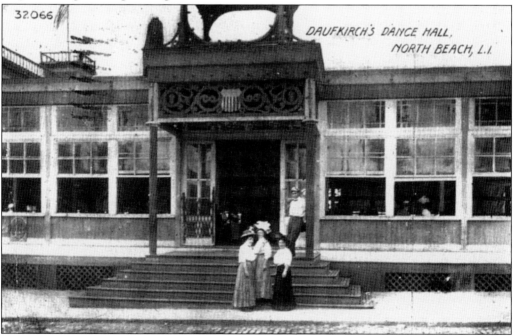

It seems strange today, but in the early 20th century, ladies wore their Sunday best to North Beach. Dresses, hats, jackets, and ties were the public fashion of the day, especially on special outings. Many young ladies came alone to North Beach with the hopes of attracting a young man to treat them to many of the amusements.

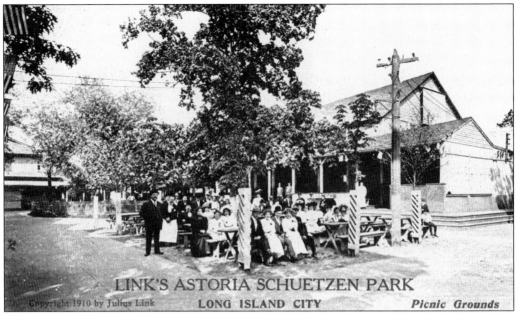

LINK'S ASTORIA SCHUETZEN PARK

Copyright 1910 by Julius Link LONG ISLAND CITY *Picnic Grounds*

The rise and fall of Schuetzen Park, a beer garden at the corner of Steinway Street and Broadway, paralleled the local community called the "German Settlement." Between the years 1870 and 1924, the park was one of the foremost political forums, even drawing in presidential candidates. Events that signaled important milestones in the borough's history were held here, as the inaugural meeting of the Queensboro Bridge Celebration Committee in 1908.

Scheutzen Park, Stineway Avenue, Astoria, L. I.

Schuetzen Park, in being open year-round, was an important setting for social events. In an age rich with clubs, many organizations met and held functions there. African American churches as well as Deutscher Mannenchoir singing groups were equally welcome. It mirrored the working-class character of the community: all were equally treated regardless of background. This park was at the southeast corner of Broadway and Steinway Street.

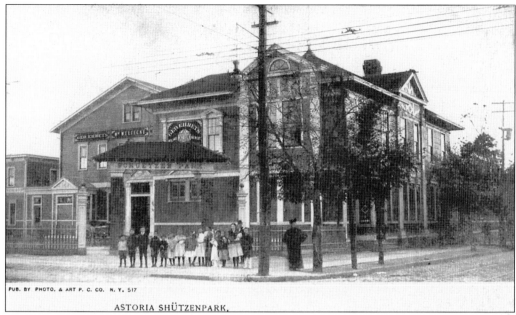

ASTORIA SHÜTZENPARK.

Schuetzen Park, Scheutzen Park, and Shützen Park may have different spellings, as indicated in all these postcards, but they are all the same place. *Shützen* is the German word for "shooting," a popular sport at these galleries. There were also dancing pavilions, picnic tables, and plenty of trees attracting several generations of people from Astoria and the surrounding areas. In its latest years, outdoor movie presentations lured patrons every weekend.

Well into the 1940s and 1950s, postcards were a cheap and effective way to promote places like clubs and bars. The Silver Palm, located at 45–16 46th Street in Sunnyside, was advertised as "the Show Place of Long Island." An elegant nightspot, it was a favorite of GIs during World War II who were home on leave.

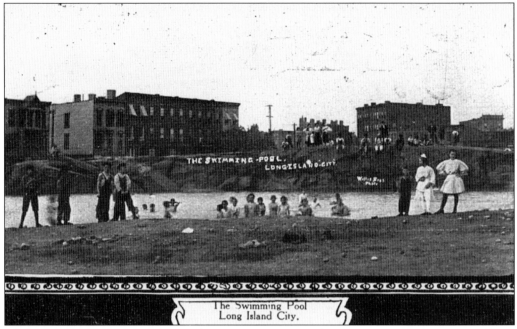

The Swimming Pool
Long Island City.

Although there were many forms of recreation in Long Island City, not everyone was able to enjoy them. The cheapest and easiest was just an open pit in Dutch Kills filled with water. Almost certainly polluted with industrial, animal, and human wastes, these young children do not seem to mind as they spend an afternoon wading in the muck.

Civic Club, Jackson and Skillman Aves., L. I. City.

The plans for the Queensboro Bridge doomed a few old landmarks in the immediate vicinity of the plaza. The Civic Club, just south of 41st Avenue (Skillman Place) and facing Jackson Avenue, was razed in November 1907. The Ancient Order of Hibernians and the American Independent Lodge No. 110 are two of the groups that met there.

122

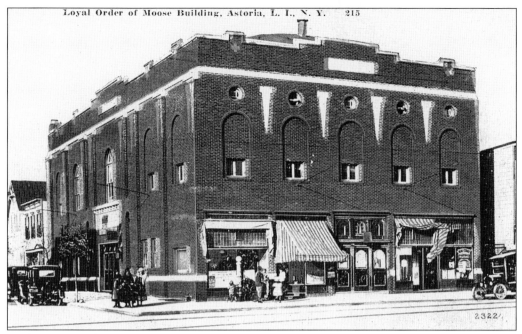

At the corner of Broadway and 41st Street stands the Loyal Order of Moose building, erected in 1922. The Moose, a fraternal organization, allowed other groups to utilize its space such as the Frank Small Dancing School. Years ago, the Moose hall held a popular weekly bingo game that was open to everyone.

The Elks' Home was once located in Hunters Point near Jackson Avenue. Needing a larger home for their growing membership, they abandoned this building for a new location in Elmhurst on Queens Boulevard. The Benevolent and Protective Order of the Elks is dedicated to good fellowship, patriotism, and community service. The building is today a union hall on 44th Drive in Hunters Point.

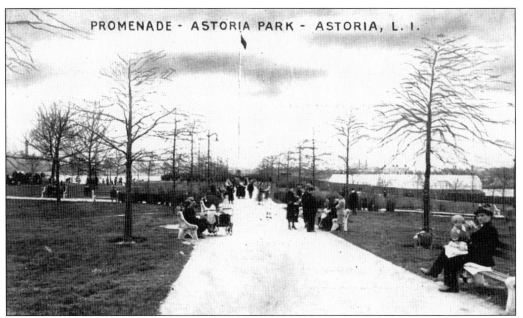

PROMENADE - ASTORIA PARK - ASTORIA, L. I.

In October 1913, the City of New York acquired 56 acres along the East River for a park. Originally called William J. Gaynor Park after the mayor (1910–1913), in December 1913, the name was changed to Astoria Park. This path, in the center of the park, paralleled the East River. In 1936, major construction in the park created Astoria Pool, and extensive tree plantings rerouted the old footpaths.

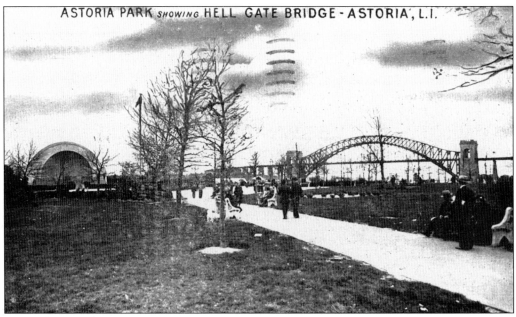

ASTORIA PARK *SHOWING* HELL GATE BRIDGE - ASTORIA, L.I.

In its early days, Astoria Park was equipped with two playgrounds, six tennis courts, an athletic field, three baseball diamonds, a wading pool, this band shell, a comfort station, and walkways. This view is just south of the future base of the Triborough Bridge. The details of this band shell's brief life are obscure.

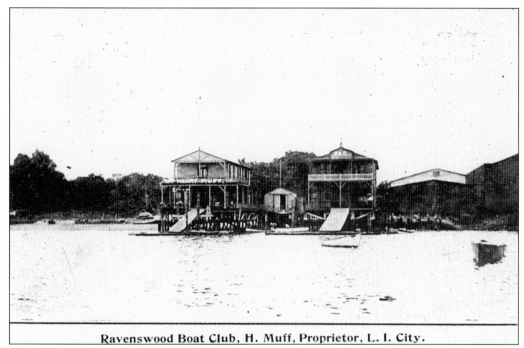

Ravenswood Boat Club, H. Muff, Proprietor, L. I. City.

In years past, numerous boating clubs had their boathouses along the shoreline of northern Queens in the East River near North Beach. The Ravenswood Boat Club and Muff's Boat House are some of the boathouses located here. These boat clubs often raced against each other in regattas. This is today's Bowery Bay Boat Club, home to recreational boaters.

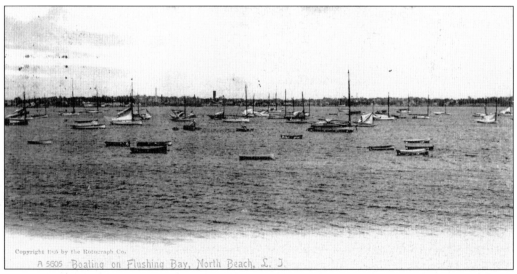

A 5605 Boating on Flushing Bay, North Beach, L. I.

The number of boats moored on Flushing Bay reflects the link the local community had to the water. At this time, south of North Beach, there were magnificent mansions along the shoreline, with stone and cement stairways to the water's edge. Access to the shoreline was severely curtailed in later years by industry, power plants, water treatment plants, and the Grand Central Parkway, a highway built by Robert Moses.

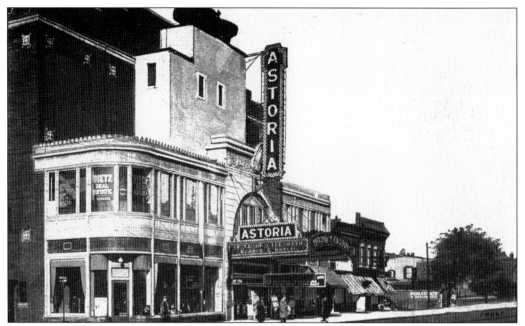

The Astoria Theater, designed by Thomas Lamb, opened in November 1920 as a vaudeville house. Acquired in 1923 by Loew's Theaters, it became a one-screen venue with over 2,700 seats. Located on 30th Avenue and Steinway Street, stars such as Judy Garland appeared on its stage. It closed on December 26, 2001, and today is used for office space, a gym, and retail stores.

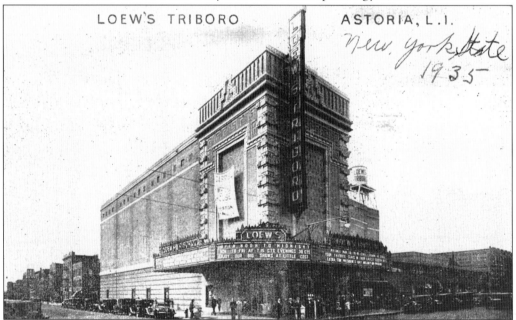

Loew's Triboro opened in 1931, with Marie Dressler in *Reducing* on screen and six acts of vaudeville. Advertising claimed over 3,000 seats in a "palace of dreams!" Designed by Thomas Lamb, the interior lobby was surrounded by chairs as elegant as thrones. The auditorium ceiling was painted with an artificial sky with twinkling stars and drifting clouds. Located at 28th Avenue and Steinway Street, it was demolished in 1974.

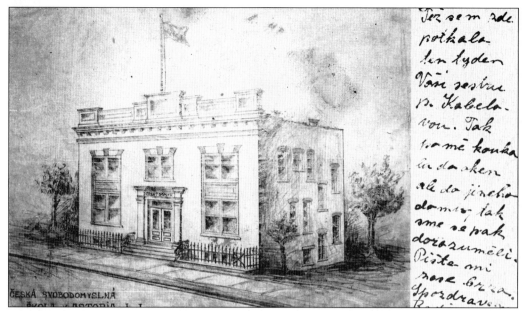

The cornerstone of Bohemian Hall, at 29–19 24th Avenue, bears the inscription in Czech, "founded 1910." Owned by the Bohemian Citizens Benevolent Society of Astoria, members recite stories of raising funds—a penny a brick—and using members who were masons, plumbers, and electricians to build the hall. Carved over the doorway are the words *Cesky domov*, meaning "Czech home." Bohemian Hall is a place where everyone feels at home.

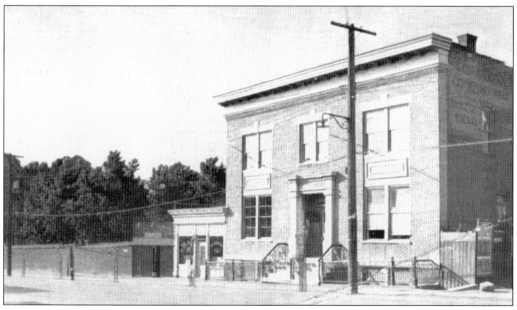

Originally, a wooden wall surrounded the beer garden at Bohemian Hall. At one time, New York City could boast of hundreds of beer gardens. Today only Bohemian Hall and Park, listed on the National Register of Historic Places, survives to carry on this proud tradition. The original formula of the beer garden is never outdated—a hot night, cold beer, and good friends!

Across America, People are Discovering Something Wonderful. *Their Heritage.*

Arcadia Publishing is the leading local history publisher in the United States. With more than 3,000 titles in print and hundreds of new titles released every year, Arcadia has extensive specialized experience chronicling the history of communities and celebrating America's hidden stories, bringing to life the people, places, and events from the past. To discover the history of other communities across the nation, please visit:

www.arcadiapublishing.com

Customized search tools allow you to find regional history books about the town where you grew up, the cities where your friends and family live, the town where your parents met, or even that retirement spot you've been dreaming about.